A GEHENNA FACSIMILE

THE DRAWINGS OF JACOB DE GHEYN II
BY J. RICHARD JUDSON

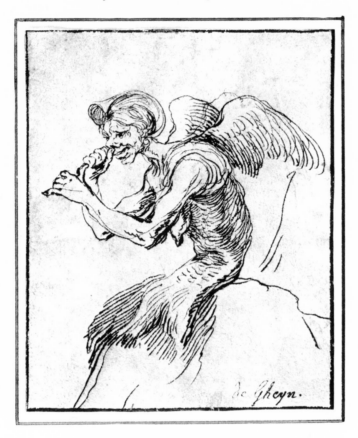

GROSSMAN PUBLISHERS

NEW YORK

MCMLXXIII

Copyright© 1973 by J. Richard Judson
All rights reserved
Published in 1973 by Grossman Publishers
625 Madison Avenue, New York, N.Y. 10022
Published simultaneously in Canada by
Fitzhenry and Whiteside, Ltd.
SBN 670-28399-1
Library of Congress Catalogue Card Number: 72-95371
Printed in U.S.A.

For
Walter F. Friedlaender
&
J. G. van Gelder

Prefatory Note ❧ One cannot deal with the work of Jacob de Gheyn without first acknowledging the labors of the great Dutch art historian and connoisseur, J. Q. van Regteren Altena, whose sensitively written and carefully documented dissertation, published (with thirteen illustrations) in 1936, is the standard work and will remain so until he completes his exhaustive monograph on the de Gheyn family. However, until this book is ready, it is a pity that de Gheyn should remain generally unknown. Therefore it seems appropriate that a representative selection of his drawings should be presented by a press directed by one of the most gifted of modern draughtsmen. ❧ The author wishes to take this opportunity to thank the private collectors and the staffs of the following Print Rooms for their numerous kindnesses which made this book possible—*Amsterdam*: Professor J. Q. van Regteren Altena, P. & N. de Boer Foundation, Gemeente Museum, Collection Fodor, Print Room, Rijksmuseum. *Berlin*: Print Room, Staatliche Museum. *Brunswick*: Print Room, Duke Anton Ulrich-Museum. *Brussels*: Collection de Grez Royal Museum. *Chicago*: Print Room, Art Institute. *Copenhagen*: Print Room, Royal Museum. *Darmstadt*: Hessisches Landesmuseum. *Frankfurt, A./M.*: Städel Institute. *Groningen*: Museum of Oudheden. *Haarlem*: Teyler Foundation. *Leiden*: Print Room, University of Leiden. *London*: Print Room, British Museum, Victoria & Albert Museum, Witt Collection, Courtwauld Institute of Art, London University. *Munich*: Graphische Sammlung. *New Haven*: Yale University Art Gallery. *New York*: The Pierpont Morgan Library. *Oxford*: Ashmolean Museum, Christ Church. *Paris*: Dutch Institute, Collection F. Lugt, Print Room, Ecole des Beaux-Arts, Print Room, Louvre Museum. *Rotterdam*: Print Room, Museum Boymans-Van Beuningen. *Stockholm*: National Museum. *Vienna*: Albertina. *Weimar*: Schlossmuseum.

J. R. J. Northampton, 1968.

The years that stretch from Lucas van Leyden to Rembrandt are the golden age of Dutch drawing. Almost unknown to all save specialists is the work of Jacob de Gheyn II. In their infinite variety and splendor De Gheyn's drawings are second only and sometimes equal to the creations of Rembrandt himself. De Gheyn, who was born in Antwerp and worked in Haarlem, Amsterdam, Leiden and The Hague, was recognized in his time as a giant. He has been all but forgotten in our time, to our loss. To rediscover him now is to experience a shock of recognition. ❧ There were three artists named Jacob de Gheyn, all of the same Utrecht patrician family.[1] The artistic branch of the family originated in a romantic way. Around 1532 the first Jacob was born on a ship sailing to Amsterdam on the Zuider Zee. Little is known about his life or achievement except for his stained-glass windows in Antwerp and Amsterdam, which were generously praised by Carel van Mander—the Dutch Vasari—in his *Het Schilder-Boeck* of 1603-1604. This de Gheyn left Utrecht and was admitted to the painters' Guild of St. Luke in Antwerp in 1558. Seven years later, in 1565, Jacob de Gheyn II was born. When he was fifteen, the family returned to Utrecht. Two years later the father died. The son, by then well versed in glass painting, completed his father's unfinished work. The young man also painted miniatures and tried his hand at engraving. His excited experiments with the burin led him to Haarlem ca. 1585, where for two years he studied with the great Hendrick Goltzius. De Gheyn and Goltzius continued in their intimate relationship [3, 11] until the latter departed for Italy in 1590. Then, with Goltzius gone, de Gheyn set up his own shop in Amsterdam. ❧ We next hear of him in the spring of 1591 when the young Utrecht jurist and art connoisseur Arnoldus Buchelius was brought to de Gheyn's studio by the goldsmith Boonhoff. The earliest evaluation of the young de Gheyn appears as an entry in Buchelius' diary. He writes: "I saw that a ripe talent flourishes in him, when he fills the copper plate with pleasing images with his fine burin." At the end of the visit, de Gheyn, Buchelius and Boonhoff visited the famous Amsterdam collector Jacob Razet, and they later dined and wined with friends at the "Golden Falcon." They remained in each other's company for several days visiting theaters, inspecting the group portraits in the "Doelens" and ending up at a brothel—"*hospitium ut in limini videbam castitati inimicum*"—an estimate corroborated by van Man-

9

der, who criticizes de Gheyn during these Amsterdam years for having neglected study for amusements. ✒ During the following year Buchelius again called on de Gheyn who showed him a series of engravings representing the Twelve Apostles. In a letter to his good friend Isebrant Willemsen in March, 1592 [15], de Gheyn apologizes for sending only a brief message "because the Apostles demand that I remain constantly in their company, in order that they take leave of me within a month and terminate their sojourn with an honorable banquet which will be paid for by Master Spruyt at the exchange, as they have lived upon me for a whole year. As I believe they are resolved to go in pilgrimage to Frankfurt, I expect they will rejoice that their journey falls in the summer, as they have hardly a shoe to their feet." ✒ During the 1590's, de Gheyn not only executed engravings after his own designs[2] but also after drawings by Goltzius as well as other leading Dutch artists of this time—Carel van Mander, Cornelius van Haarlem and Dirck Barendsz. It was at this moment that de Gheyn met Abraham Bloemaert, who was then living in Amsterdam, and made a number of engravings after his designs. Accompanying the engravings were complicated texts added to the plates by either the artist or a scholar like Hugo de Groot. ✒ Very often the artists were involved in literary and theatrical ventures and de Gheyn was an active member of the Rhetoricians' Club first in Amsterdam and later in Leiden. De Gheyn's interest in costume is evident in ten engravings, *The Masks*, which he published himself sometime after 1595. In 1598, he played the leading role in a Rhetoricians' pageant honoring Prince Maurice's visit to Amsterdam. ✒ In 1595 de Gheyn married Eva Stalparts van der Wijele, the daughter of a patrician family of The Hague. With her he moved to the university city of Leiden, where, according to van Mander, the artist found "unusual and inconceivable peace and quietness" conducive to assiduous work. ✒ Two years earlier the States General in The Hague and the magistrates of Utrecht and Gouda made payments to de Gheyn for an engraving illustrating the Battle of Geertruidenberg. This print met with success and four years later, in 1597, he was again commissioned by the States General to make another commemorative engraving, this time in honor of the great victory of William, Prince of Nassau, over the Spanish at Turnhout on January 24, 1597. Three years later de Gheyn designed a medal in honor of

Prince Maurice's victory at Nieuwport. ❧ It was during the Leiden years that de Gheyn established himself as a mature and prosperous artist. In 1598 he was admitted as an engraver and painter to the Guild of St. Luke in The Hague, and in the following year he was able to endow his son, Jacob III, with 3000 gulden, to be received on his twenty-fifth birthday. Important commissions came to him and he was busy portraying the leading citizens of Leiden and Amsterdam. He engraved the portraits of Professor Ludolf van Collen, the famous Leiden engineer and geodesist, and of Jan van Hout, the Secretary of the city of Leiden. His engraved portrait of Professor Carolus Clusius, the learned doctor, celebrated botanist and founder of the Botanical Gardens in Leiden, suggests a friendship that might well have played an important role in his later drawings [44–50, 52–55, 62–64] and in his paintings of plants, flowers, insects and small animals. De Gheyn was also apparently a member of the Leiden circle of art collectors. ❧ De Gheyn moved to The Hague sometime before 1603, but he did not lose touch with his Leiden friends. For example, in 1606 and in 1608 he illustrated two volumes of poetry by the Leiden Latinist Daniel Heinsius and in 1610 the title page of the *Nassau Wreath of Laurels* for Jan Orlers, the future mayor of Leiden, early biographer of Rembrandt, and nephew of Jan van Hout.[3] In 1616 he designed a print published by Andries Jacobsz. Stoc[kius] illustrating the annual anatomy lesson performed by his close friend, the Leiden physician Pieter Paaw. De Gheyn also continued to have family and financial interests in Leiden well after he moved to The Hague. ❧ Why did de Gheyn move to The Hague? Probably because there were greater opportunities there—given his association with the Court since 1593 and his excellent family connections; in 1603 he was living in his wife's grandmother's house in the fashionable Voorhout. More importantly, around this time de Gheyn was seriously turning his attention to painting. Van Mander informs us that de Gheyn's wish to paint became so strong that he stopped engraving and deplored the time and labor lost. His earliest known painting,[4] a portrait of the famous stallion captured in 1600 by Lewis Gunther of Nassau from the Archduke in the Battle of Nieuwport, was painted at the request of Prince Maurice. ❧ De Gheyn's close association with the military at the Court continued and in 1607 he published, with illustrations, one of the earliest manuals of arms.

This ambitious book contained one hundred and seventeen plates and was used to train the Dutch army. As van Regteren Altena points out, the right to publish the *Wapenhandelinghe van Roers, Musquetten ende Spiessen: Achtervolg-hende de ordre van sijn Excellentie Maurits Prince van Orange* was very likely granted in 1606 some ten years after it was commissioned, for it was considered unwise to bring it out before the signing of the armistice with Spain was assured. ◦• De Gheyn's work for the Court also reflected his scientific and architectural interests. In 1603, on the occasion of Prince Maurice's outing on the beach at Scheveningen, he executed a number of studies [31–33] for an engraving (cut by Swanenburgh) of Simon Stevin's sailing-car. On still another occasion, we hear of de Gheyn's activities as an architect for the Court. Constantijn Huygens writes that de Gheyn "was soundly acquainted with the laws of architecture as delivered to us by the ancients and, helped by his own talents, applied them with great discrimination and delicacy, so that, especially for this reason, at an advanced but still vigorous age, he rendered great service to Prince Maurice. For this Hero, who all his life had taken no pleasure in building, began, towards the end of his life, to make some attempts at it, which seemed to promise the erection of greater monuments, if he had lived longer. This is witnessed by the pavilion that he had built at the foot of the Palace in The Hague in the garden, which de Gheyn had also designed. He relied herein especially on the help and advice of de Gheyn, who was not unwilling to refresh his spirit, hitherto exhausted by more strenuous labor, with such agreeable work, and who, by the introduction of ornaments such as hedges, flower beds, fountains and other such decorations, exerted himself for a master who was not ungrateful and who amply rewarded his industry. For de Gheyn, first for Maurice and then for Frederik Hendrick (my master) worked for a very high honorarium. He left unfinished the work on which he had begun of imitating in the Italian manner high rocks standing in water, and transferred both the work and the reward to his only son Jacob." The actual garden is described in Hendrick Hondius' *Institutio Artes Perspectives* (The Hague 1622), as being enclosed by two circular "galleries" (hedges) and a "daintily painted pavilion" [111].[5] De Gheyn also served the Court as an artistic advisor, counseling Prince Frederik Hendrick on the purchase of pictures, as noted in several entries in Jan

Breugel's diary for 1627. ✢ In 1627, de Gheyn lived next door to Huygens, the Secretary to the Prince, in the Lange Houtstraat, and Huygens tried to engage him as a drawing teacher for his son, but with no success, although earlier he had taken on several pupils. Van Mander tells us that Jan Saenredam, Zacharias Dolendo, Robert in Amsterdam and Cornelis, then in France, studied with de Gheyn. ✢ For one whose humanistic interests were so broad, de Gheyn traveled little outside of The Netherlands. He very likely visited England, but for some curious reason he did not conclude his student years with the customary trip to Italy. This may reflect his rejection of Italian ideals for a Northern vision of reality. ✢ It is not absolutely certain that de Gheyn, upon his death in 1629, was a member of the Reform Church or a liberal Catholic. It has been suggested on the basis of a drawing in David de Kempenaer's *Album Amicorum*, illustrating *Christ and His Disciples in a Boat on a Stormy Sea (Storm on Gennesaret?)* [6], inscribed "Fear Not," that de Gheyn was expressing a Protestant attitude. This idea has been further reinforced by the Berlin drawing of *A Man at Prayer and Another Touching his Shoulder* [5], inscribed "Simple faith and good works are more valid to God than lofty Churches." Although the image in the *Album Amicorum* has a long Catholic tradition, the intense piety of the *Album* suggests the book-oriented piety of French and Dutch Protestants around 1600. Moreover, when considered in the light of the Berlin sheet, it is most likely that de Gheyn was a practicing Protestant.

II *Subject matter and style* From the outset de Gheyn moved in the ambience of the intellectual life of his time and was in touch with the most prominent scholars and scientists in and out of the Netherlands.[6] His earliest documented work is a splendid *Portrait of Tycho Brahe* [14], the famous Danish astronomer and alchemist, although this drawing was not done from life. There followed a large number of portraits in the style and format of his master Goltzius [15, 16, 18, 21]. In 1599 he drew in silverpoint, and then engraved after it, a portrait of the brilliant fifteen-year-old scholar Hugo de Groot [17], with whom, some three years earlier, de Gheyn had collaborated when the youngster had composed Latin texts for de Gheyn's prints. Again in 1599 he drew and engraved a posthumous portrait of the scholar statesman Philip Marnix van Sint Aldegonde [19], and the following year he sketched Prince

Maurice of Nassau. ❧ De Gheyn's interest in rendering scientifically correct studies was first awakened by Goltzius, but it was not until his Leiden years that he began making drawings of plants, insects and animals [41–55, 57, 61–64]. In the handsome ornamental border surrounding his engraved portrait of the botanist Carolus Clusius—which appeared in the latter's *Rariorum Plantarum Historia* (Antwerp, 1601)—we witness de Gheyn's engagement with scientific naturalism of the sixteenth century.[7] Clusius, before accepting the chair of Botany at Leiden in 1589, had attained a wide reputation in Western Europe. He had worked and studied in great universities and important courts.[8] From 1573 until about 1587 he directed the Imperial Gardens in Vienna for Maximilian II and took time to explore the botany of the mountains of Austria and Hungary, a study of which he published in 1583. Clusius came to Leiden not only as an expert in botany of the Old and New Worlds, but also as a distinguished philologist, jurist, philosopher, historian, epigrapher and, most important for his relation to de Gheyn, zoologist and mineralogist. While at Leiden, Clusius planned and directed the new botanical garden, completed by 1594, of which de Gheyn made an engraving. There can be little doubt that some of de Gheyn's early paintings, watercolors and drawings of flowers, insects and small animals such as mice, turtles, frogs and snakes [45–47, 49], were stimulated by Clusius. The watercolors, sometimes heightened with pen and ink, are executed on small sheets of vellum or paper [44]; often, as in his drawings of flies [48], they are very tiny. They are done with sensitive care and catch the curious evanescence of flies. These separate sheets, now in various European collections, originally must have been bound together with several books of the type made by Georg Hoefnagel for Rudolf II's Natural History Library in Prague. Van Mander informs us that Rudolph II purchased a "small book wherein de Gheyn had made some flowers and other diversions from nature, with also many small beasties." This book is very likely the one in the possession of Frits Lugt (Dutch Institute, Paris)[9] and contains twenty-two pages of magical watercolors on vellum all signed by de Gheyn and dated 1600 to 1604. One watercolor of 1600 [43] is of a vase with three tulips, with a number of small insects crawling about on the tabletop while a butterfly rests on a petal. Every botanical and zoological detail is rendered with perfection. This pre-

14

cision is combined with a magnificent sensitivity in the use of color and in the manipulation of nuances of light and shadow—all producing a heightened and enhanced perception of nature. This achievement, as Bergström has pointed out, marks a break in the tradition of Northern flower painting because now the artist has studied nature as an artistic whole and not only in its discrete parts. The illustrations in the Lugt album and the separate drawings of insects, flowers and fruit, such as the *Black Berries* [62], in the Print Room, Amsterdam, depict each and every property, but not at the expense of the total design. In his *Three Roses* of 1620 [63], in the Print Room, Berlin-Dahlem, de Gheyn by his rapid deployment of the line in breadth and shape, and by varying the amount of ink, produces a masterpiece of art and science. He is not simply making a scientific analysis of the parts in the cold, analytical fashion of some herbals of the sixteenth century; in the frilled and scalloped petals of the roses there is a love for the flower itself wrought out in the careful establishment of light patterns by a most sensitive pen. In this way he reflects, toward the end of the sixteenth century, a change in attitude, very likely based upon a return to the precepts of Leonardo da Vinci and Albrecht Dürer. This trend was stimulated by the demand of wealthy collectors for albums richly illustrated with their favorite flowers painted and drawn with both scientific and pictorial brilliance. ♣ De Gheyn's illustrated books, judging from the book in the Lugt Collection, and van Mander's text, not only contained magnificent flower representations but also small "beasties" which were separately treated. His obvious interest in entomology very likely reflects both his contact with Clusius and the general interest in this subject during the sixteenth century, manifested by the appearance of numerous illustrated zoological books. It was also at this time that the great natural science collections were being formed containing specimens from all parts of the known world. De Gheyn, following closely in the tradition of Georg Hoefnagel and probably under the tutelage of Clusius, produced numerous drawings and watercolors [45] of actual specimens.[10] Such drawings as those in the Print Room, Frankfurt, of flies [48], a lizard or a salamander [44], a snake [47], a large hermit crab [54] or the sheets of frogs and mice in the Print Room, Amsterdam [45, 46] were all drawn from fresh or preserved specimens. It is also possible that de Gheyn, a man of considerable

wealth, had his own collection of botanical and zoological wonders. De Gheyn studied the anatomy of his subjects carefully and very likely used a magnifying glass in order to reproduce, with such precision, the common housefly [48]. The microscope was available as early as 1590, thanks to the experiments of Johannes and Zacharias Janssen. ☙ That de Gheyn was familiar with laboratory procedures is clearly illustrated in his marvelous representation of a frog in four positions [45]. Only the pose in the upper right-hand corner is natural for the animal itself. In the remaining positions, the frog seems to have been manipulated to reflect the principles of anatomy. The upper left is the position for general dissection. It is possible that the lower left illustrates the death of the frog at the moment it is dropped into the preservative and utters its last croak. One finds a similar realism in the magnificent watercolor, heightened with pen, representing a house mouse in a variety of poses [46]. De Gheyn reproduces vividly the furred beauty of the animal. Here again, such details as the small eyes are scientifically correct and prove that de Gheyn was committed to the true representation of nature and most likely studied them under magnification. ☙ De Gheyn's interest in animal life was not restricted to the laboratory. Following the example of his teacher Goltzius and others, he drew from nature dogs, horses [51], lions [41], donkeys [55], goats, storks [53], dead pigeons [52] and the head of a skinned-ox [42]. A work horse, grazing quietly [51]; a high-strung circus horse curbed by an attendant [92]—his pen sought out the differences, a soft, atmospheric line in the former, a charged line in the latter. His vibrant sketch in the Berlin Print Room of *Four Heads* [55] seems to be a study in comparative anatomy of a horse and a donkey. The thinner more delicately drawn horses' heads above are contrasted with the cruder broader donkeys' heads in the center and below. ☙ Quite in contrast to his drawings of large animals like horses and lions [41, 51] are his delicate pen drawings of birds. In his *Study of Storks* [53] he shows us how the bird walks, stands, cleans and feeds himself. Opposed to this study of life is his equally moving rendering of the death of birds. His two dead, plucked pigeons [52] are poignant, frightening, and begin to inhabit the realm of the grotesque. ☙ De Gheyn's desire to portray fantastic but credible shapes (in the case of the pigeons) perhaps brought him to the border between the real and the imaginary. A fine example of this is the

16

1609 drawing of two rats and three frogs [61]. To begin with, one is not sure that the two animals supported by a stick are really rats. They have long and elegant fingers, their upper arms are too long, there are strange differences in the length of their toes, and their tail skeletons are too conspicuous. The animal to the right appears to be skinned to the end of the nose, which explains the exaggerated appearance of the vertebrae second muscles. Furthermore the positions of the so-called rats are those assumed by humans in anatomy illustrations[11] and the arms and hands holding the top of the staves seem to be more human than rat-like.[12] At this point we are only a step away from the recognizable but grotesque combinations of human and animal shapes which de Gheyn invented for his many witchcraft scenes[95]. ⚫ De Gheyn's scientific study of animals was complemented by a similar involvement in the field of human anatomy. When he moved to Leiden, he found himself in the center of anatomical studies for northern Europe. It was here that the second oldest permanent anatomical theater had been established in 1594[13] and three years later, under the direction of Dr. Pieter Paaw, a separate building was erected solely for anatomy demonstrations. Paaw was internationally known as a medical historian and anatomist, and de Gheyn must have attended his public anatomy lessons. De Gheyn met the Paaw family almost immediately upon his arrival in Leiden, and in 1596 he made an engraved *Portrait of Jan van Hout*, Dr. Paaw's father-in-law. This connection appears to have endured well after de Gheyn's departure from Leiden around 1603. As late as 1616, de Gheyn made a design for a print executed by Andries Jacobsz. Stoc[kius] of *Pieter Paaw's Anatomy in Leiden*. We have other bits of evidence that further indicate a connection between de Gheyn and Paaw. There are a number of magnificent drawings which must have originally been part of anatomy books that have since been cut up and dispersed. A splendid example of one of these is in the Collection Lugt, Dutch Institute, Paris. This sheet [65], inscribed with the number twenty-nine, depicts the anatomy of the leg in four different positions. Cut at the joint with the skin still evident, the leg is drawn with great care in illustrating the various muscles. It is anatomically correct, and, as in his drawings of small animals, de Gheyn must have used a preserved specimen.[14] The same thing can be said for the drawing in the Print Room, Rijksmuseum, Amsterdam [66],

bearing the number thirty, of an arm, stiff with rigor mortis. Single arms were preserved in the anatomical theater for study purposes and, as has been recently shown, one was used by Rembrandt in his *Anatomy of Dr. Nicolaas Tulp*, Mauritshuis, The Hague.[15] It is possible, owing to the similarity in dimensions, that both the Amsterdam and Lugt drawings may be from the same sketchbook. These two drawings are not only scientifically correct, but they also exploit light and shadow beyond reportage. This same spirit is present in his drawing of human skulls. In his *Study of a Skull*, Print Room, Berlin-Dahlem [67], both the solid areas and the deep dark crevices gave de Gheyn a chance to show his ability to use light for both artistic and structural purposes. In spite of all of the carefully drawn details such as the sutures, the chiaroscuro contrasts weld the parts into the whole. The skull later served an important role in a new type of subject matter and became one of the key symbols for the *Vanitas-Still-Life*[16] which de Gheyn, as far as we know today, introduced into Dutch art in his recently discovered signed and dated 1603 *Vanitas*, Private Collection, Sweden.[17] ❧ Along with his study of human anatomy in the laboratory, de Gheyn also observed men and women in their daily life and work. He drew the body and its parts in a variety of attitudes following the tradition of Leonardo da Vinci, Albrecht Dürer, and Lucas van Leyden, as revived at the close of the sixteenth century by Hendrick Goltzius, among others. For example, his 1604 *Study of Nine Heads* [81] catches a variety of positions and expressions which combine to give us insight into the mood of each head. In this drawing a range of emotions is indicated from the intensely serious profile view at the top center to the animated, voluble expression of the head to the right, and down below to two completely relaxed sleeping heads. The diversity of the curving, zig-zag or scratchy pen preserves these moments drawn from life with a breadth and spontaneity hardly to be equaled in the history of drawing and certainly never before found in Dutch art. During these years de Gheyn also made splendid pen-and-chalk drawings of heads and hands[18] [73, 76, 77, 79]. Once again his ability to create more than just an accurate physiological rendering is evident. Here the pairs of hands and heads impart a variation in mood. This interest is again seen in still another study in the Print Room of the Rijksmuseum, Amsterdam [80]. It is here that the concentration of the

young man in the Berlin drawing [81] is elaborated by the addition of a book and table, thus bringing us closer to de Gheyn's intimate genre scenes such as the *Young Artist Seated at the Table*—perhaps Jacob de Gheyn III [86].The Amsterdam drawing [80] also contains two beautifully foreshortened expressive hands[19] which lead to the studies devoted exclusively to hands. Whether he worked with black chalk [73] or with pen and ink, the hands reflect a range of emotions from the relaxed to the tense and nervous. In the black chalk drawing, de Gheyn studied a variety of hand positions, which served him in his full-length figure drawings. The relaxed hand in the bottom center appears again in the marvelous *Study of a Young Man Resting on the Ground* [82] which also uses the sleeping head in the bottom right corner of the Berlin *Study of Heads* [81]. In this full-length reclining figure, de Gheyn presents us with a portrait of relaxation which stresses a mood as well as a physical state.[20] ❧ It was also at the turn of the century that de Gheyn observed and drew the female form from living models. This practice was not unusual, but de Gheyn's way of seeing and presenting the nude was revolutionary Whereas Goltzius and his contemporaries drew nudes that were still based on the anti-classical ideal, de Gheyn's *Sleeping Woman* [70] is a natural figure. De Gheyn does not draw a nude based upon an ideal, classical or anti-classical, but a living woman with all of her beauty and blemishes. She is not posed but drawn while actually asleep and de Gheyn not only achieves a sense of a resting form surrounded by bed clothes but also suggests the atmosphere of the bedroom. There may be a hint of Venice in this study, but the moment de Gheyn put the chalk to paper, the ideal form of Venice was abandoned. We are now faced with genre, pure and simple, which de Gheyn, reintroducing a Dürer notion, carries outside of the sleeping chamber to other activities which gave him the chance to study the body in a variety of positions and movements. A splendid example is the sheet containing *Studies of Four Women* [69]. Three of these women are "caught" in the process of combing their hair and their deep concentration on this part of the morning toilet is brilliantly established by the artist. He takes a very ordinary genre activity and raises it to a monumental level. Again, as in the Brunswick sheet [70], the figures are carefully drawn after nature with a variety of lines that illustrate de Gheyn's un-

derstanding of anatomy and the skin that covers it. This very same interest in life and its combination of the ugly and the beautiful is also clear in numerous other sheets from his hand, especially in the *Standing Woman at her Toilet* [68]. Perhaps these two were part of a series depicting a woman at her toilet. ☙ De Gheyn reports further on family life in his magnificent sketches of intimate moments in the home. We find a mother tenderly holding a baby on her lap [84], draining milk from her breast [71] or studying a drawing book by candlelight with her young son [85]. In still another moment a mother feeds a child while her husband[?], the bailiff Halling, raises his glass [83]. Out of the realm of the nursery but equally personal and moving is the sketch in Frankfurt containing two views of the same man on his deathbed, perhaps Carel van Mander [22]. De Gheyn searched everywhere for his subjects, whether indoors [69, 85, 86] or out in the fields 27, 30], along the seacoast [31, 32, 88, 89], at a picnic [87] or in the cities and towns [29, 90, 91]. Because of his commission to design an engraving of Simon Stevin's sailing-car built for Prince Maurice of Orange, de Gheyn made a number of trips to the beach at Scheveningen. The results of these visits are found in his pen study of a walking couple and seated gentlemen [33] and also in his sketch of fishermen mending their nets [32]. De Gheyn's small and delicate pen strokes create figures on a miniature scale while other drawings of the same subject, on a larger scale, render a more powerful impression of fishermen busy with their daily chores. This is so splendidly achieved in the *Study of Two Fishermen Bending over a Vat* [89] and the *Drinking Fisherman* [88] that one can only recall the later works of Frans Hals where very much the same effect of catching and preserving a moment will be achieved, but this time in painting. De Gheyn's eye and hand were equally responsive to the beauties of the pastoral life [75]. With silverpoint he delineates the lyrical milieu of the shepherdess and with heavy pen lines the rough world of the fishermen. De Gheyn's interest in life is boundless, as can be seen in his majestic pen drawing, full of pathos, of a prisoner or madman [91]. These examples of de Gheyn's absorption and interest in the simplest of subjects could easily be supplemented. However, what strikes one as most important in de Gheyn's preoccupation with the preservation of very minor activities from daily life [69] is the significance which they take on for the

participant. In this way de Gheyn introduces a new vision into Dutch art[21] which will be so important for the future and especially for Rembrandt. The connection with the latter seems most obvious in the illustration of intimate family activities [70, 71, 84]. Whether or not this type of perception and its recording is a de Gheyn innovation is open to question. One cannot overlook the fact that such drawings were being made in Venice prior to his by the Friesian emigré Dirck de Vries. In 1590 de Gheyn's teacher, Hendrick Goltzius, visited de Vries in Venice when the latter was drawing family-genre scenes in a Venetian pen-and-ink style similar to what de Gheyn would do later. It is possible that Goltzius brought some of the de Vries drawings back to Haarlem in 1591, but we have no evidence that de Gheyn could have seen them. In fact, there is no documentation for personal contact between de Gheyn and Goltzius after the latter left for Italy in 1590. Given de Gheyn's overpowering interest in every aspect of nature from the tiniest of bugs and flowers to the largest of animals, there is no reason to think that he would overlook the intimate scenes from daily life and that he needed an outside source to open his eyes to this facet of life. However, regardless of the reasons for de Gheyn's turning to this subject, he was the first Dutchman to record such observations and his sensitivity may perhaps lead to Rembrandt. ✺ The same thing can be said for his drawings of nudes [68-70] which are absolutely different in conception from those drawn by his contemporaries. Goltzius' are elegant and mannered while Abraham Bloemaert's are more idealized and sophisticated.[22] De Gheyn, on the other hand, for the first time since Albrecht Dürer studies the nude both for its perfections and imperfections and produces drawings that will only be rivaled by Rembrandt's 1658 etching of the *Negress Lying Down*[23] and by the latter's pupil Govaert Flinck. ✺ De Gheyn's absorption in the study of nature and anatomy also led him to the realm of fantasy out of which he drew a number of spirited works representing humans in highly contorted positions. For example, on two occasions he places a realistic body in sixteenth-century Michelangelesque poses [72], but he uses normal proportions.[24] ✺ This vision of the human body is also present in de Gheyn's landscapes.[25] He often renders purely imaginary vistas [23, 26, 34, 35, 39, 40], while at other times he combines the imaginary and realistic [36, 37] and on still other occasions

he reconstructs nature to give us an imaginative but realistic and "pleasant" view [25, 29, 30] following the principles set down by Carel van Mander. ❧ From the very beginning of his landscape career de Gheyn, continuing in the footsteps of Goltzius, seems to have been very much touched by the mountain landscapes by Pieter Bruegel[26] and the latter's mannerist followers. De Gheyn's landscapes prior to 1600 [23, 26] are, in the main, mountain views using a mannerist space combined with fantastic mountains and trees common in the works of men like Mathieu and Paul Bril, and Joos de Momper. However, contrary to their delicate and detailed pen strokes, de Gheyn draws with very strong, thick and powerful lines creating vivid contrasts between the dark ink and white paper. This and the pronounced presence of parallel lines mixed with occasional strokes demonstrate his continued debt to Goltzius and the latter's to Venice, especially to Domenico Campagnola. De Gheyn's 1598 Louvre landscape [23] also illustrates his contact with Pieter Bruegel in the presentation of a distant view with the scratchy pen hardly indicating the shapes and forms. It is this type of distant dissolving form indicated by a quick short pen stroke that de Gheyn must have studied carefully when he executed the 1598 engraving after Bruegel's 1561 *Castle with Round Towers and River to the Left*. However, the space in de Gheyn's Louvre sheet has an additive quality and lacks the continuity and broadness of vistas present in Bruegel. ❧ In this same year, 1598 de Gheyn seems to have studied the mannerist forest scenes of Gillis van Coninxloo [24], who emigrated to Amsterdam in 1595 a few years before de Gheyn's departure for Leiden. At this time van Coninxloo was extremely important for the development of Dutch landscape and the ever inquisitive de Gheyn must have been touched by the former's imaginative abrupt use of space to create decorative woodland scenes. Like van Coninxloo, de Gheyn's drawing contains two funnels of space going back into depth starting from a single point in the foreground. This unreal space is combined with a decorative rendering of the trees which help to direct our vision into that uncertain space. In the left foreground, so typical of van Coninxloo, is a gnarled tree trunk acting as a repoussoir. De Gheyn uses the van Coninxloo compositional type but not his decorative, colorful and loose drawing technique which makes forms spread before us in light elegant patterns. De

22

Gheyn, instead, draws forceful lines in the style of Campagnola and Goltzius.

⌁ During what seems to be de Gheyn's first documented year as a creator of landscapes, 1598, his probing mind also brought him to landscapes that border somewhere between topography and a realistic-imaginative recreation of the Dutch countryside [25]. Although in this 1598 *Landscape with a Canal and City in the Distance* the space moves suddenly from the foreground to the background, and the eye is channeled down the middle with the sides closed off, the idea of trying to capture a sense of the Dutch landscape, half of which is occupied by the sky, is new. Here the spectator looks down upon a scene which lacks scale. This type of view, with its mannered space, indicates that de Gheyn was possibly experimenting with a compositional type found in the topographical views by an artist like Hans Bol who lived in Amsterdam at the same time as de Gheyn. However, contrary to Bol and the new interest in topography in general in the Netherlands at this time, the location of de Gheyn's drawing cannot be identified. It can be suggested, therefore, that he is verging upon an entirely new treatment of Dutch landscape drawing and is a short step away from the imaginative-realistic creations of the early seventeenth century. However, this drawing is, according to the preserved works, an exception in de Gheyn's sixteenth-century oeuvre. In the main, he continues to envision landscape as a possibility for creating fantastic images in the Flemish tradition. In 1599, he produces still another beautiful drawing [26] combining the vision of Bril with a Venetian drawing style. A year later, de Gheyn moves back in time and borrows a motif very popular in the Patenir circle, the fantastic geological landmass from Provence in the south of France, La Sainte-Baume, for his London *Landscape* [28].[27] De Gheyn's use of this often-repeated landmark in the sixteenth century gives still another dimension to his wide range of scientific interests. Here he combines this landmark with houses from a Flemish or Dutch village of the kind found in the topographical views first engraved in the *Small Landscapes* published by Jerome Cock in 1559–1561 of villages just outside of Antwerp. De Gheyn also includes in this drawing an ancient type of ship common in Bril and another series of disconnected Bruegel-like mountains in the distance. This drawing of 1600, although combining identifiable topographical features from different parts of Europe, demonstrates the

large number of sources de Gheyn used when composing his fantastic mountain views.[28] ❧ It is not, as far as I know, until the year 1602 that de Gheyn actually places his observations of natural landscape on paper in a realistic way [31]. And once again, he follows in the footsteps of his former teacher Goltzius. By 1600 the latter had produced his splendid drawing of the *Ruins of Bredero Castle*, Print Room, Rijksmuseum, Amsterdam, his *Dune Landscape*, Boymans-Van Beuningen Museum, Rotterdam, and his 1598 *Whale Stranded on the Beach between Scheveningen and Katwijk*, Teyler Foundation, Haarlem. These Goltzius drawings indicate a change in attitude toward landscape away from the fantastic mountain views based upon Bruegel and his more mannered followers toward a new interest in natural landscape. Dutch artists, led by Goltzius around 1600, use Bruegel's ideas but now they turn from his fantastic alpine views to his drawings of villages and farms—to the drawings made after life. This new trend appears first in Jacob de Gheyn's 1602 *Study of Fishermen on the Beach* [31], made for the 1603 engraving of the *Sailing-car of Prince Maurice of Orange*. The composition is not idealized; in its spread-out arrangement, with no central point of concentration except fishermen at work, it conveys to the viewer the atmosphere of the sea coast. The beached fishing boats with their masts extending over the horizon line, the boats in the distance with their sails silhouetted against the sky, the fishermen working in the foreground, and the imaginary position of the spectator looking down on the sea from a dune above establish a new type of beachscape which will become an extremely popular subject in the Netherlands within a few short years. ❧ This same method of executing drawings on the "spot" is also evident in de Gheyn's inland scenes of around 1602–1603 such as the beautiful Berlin drawing of a *Man Resting in a Field* [30]. De Gheyn captures the feeling of open air which envelops the scene. It is mid-day, and there are two workers and a team in the distant field on the left and a quiet village scene on the right, both extending beyond the actual picture surface. De Gheyn's short quick strokes and his use of trees to block out the village are strongly reminiscent of Bruegel's approach to nature around 1560. De Gheyn's sheet is of course a prototype for Claes Jansz. Visscher's splendid landscape drawings of the environs of Haarlem executed around 1607 which will be so important for future developments in Dutch landscape painting. ❧

About the same time that de Gheyn executes these Bruegel-like beach and field scenes, he also returns to the canal [29] as a subject. However, contrary to his earlier presentation of this subject in 1598 [25], the space is no longer mannered and cluttered but very selectively worked out. This drawing of a *Village Toll* [29] gives, as in the *Man Resting in a Field* [30], a fine sense of the atmosphere of the setting; but because de Gheyn is so attentive to the workings of one-point perspective, with arches enframing arches and a shrine placed as a deliberate accent above the center point of the foreground arch, it is obvious that this drawing was made in the studio and not directly from nature. The sheet is a contrived reconstruction of a canal. De Gheyn does not achieve in this drawing the informality of nature which will characterize most seventeenth-century "realistic" landscapes created out of the imagination. ✒ Although the de Gheyn drawings discussed above show a new interest in presenting scenes that could exist, the artist also persisted in drawing fantastic mountain views. His 1603 *Mountain Landscape* [34] illustrates his continued interest in Bril's vision of landscape while his *River Landscape* [35] of the same year combines both Bril and the earlier Patenir. These decorative and imaginative landscapes take on a variety of forms and shapes which also include composed vistas that extend far into the distance, again illustrating the Bruegel revival of around 1600. The 1603 *Landscape with Robbers* [37] borrows the van Coninxloo formula of framing both sides of a composition with trees and combines it with an open space that moves back logically into depth in layers parallel to the picture plane. De Gheyn presents us with a dune landscape near The Hague and its progression back into the distance recalls the panoramic vision of Pieter Bruegel.[29] The technique, on the other hand, is Venetian with the strong dark pen lines in vivid contrast with the white paper imparting to the land mass a heavy undulating movement similar to what one finds in the woodcuts of Campagnola and Goltzius. The scene is both poetic and natural, and in its creation depends upon the closest observation of nature transmuted into a highly original image, which is repeated in his *Farmyard Scene* [36] from the same year. A similar revival of interest in farm life also occurred in Utrecht around this time in the works of Abraham Bloemaert. However, whereas de Gheyn combined a Flemish vision of landscape with a Venetian

technique to make his highly spirited re-creations of nature, Bloemaert used Albrecht Dürer as his source to give us a lyrical view. ❧ De Gheyn's fantastic-romantic view of nature based on Bruegel, Venice and Goltzius reaches its high point in the 1609 *Landscape with Robbers* [40], wherein a sentry is stationed on a rise and looks out over a heaving, breathing landmass covered by great swirling clouds that reiterate the shapes of the mountains and hills which roll on into the distance. Here de Gheyn's brilliant pen presents us with a dramatic contrast of light and dark creating one of the great landscape drawings of Dutch art. ❧ De Gheyn's spirited genius in the field of landscape also brought him to the "other world"—that of the Devil. In his magnificent 1603 *Sowing of Tares* (Matthew 13:24–30) [1a], his drawing style and the movement back into space down the middle and off to the right side are similar to qualities we have found in the *Man Resting in a Field* [30]. Now, however, the scribbles of the pen have become more vibrant, the contrast between the ink and the paper more pronounced, and the sky is invaded by the Devil's associates riding along on goats. The peaceful scene from daily life [30] has been transformed into an unforgettable representation of a parable. ❧ De Gheyn not only studied landscape closely and then either drew it to appear naturalistic or imaginative, but he also applied this same method to meticous studies of parts of the landscape. Such sheets as his *Clump of Grass with Flowers* [57], *Study of Blackberries* [62] or his *Study of Grapes, Pumpkin or Squash and Portrait of a Woman*]50] are scrupulously careful studies of a variety of plant life. On the other hand, his fine drawings of mighty tree trunks [56, 60] stand somewhere between a realistic rendering of nature and an imaginative recreation. Such marvelous drawings as *The Old Oak and Man Seated Beneath It* [56], *The Two Tree Stumps with Roots* [60], *The Group of Trees* [59] or *The Study of Trees* [58] are all renditions made after nature but tempered by the artist's creative spirit. The studies of the tree trunks and trees, with their fantastic forms, are the forerunners of the romantic wooded landscapes which will be painted later by Jacob van Ruisdael and drawn by Govaert Flinck. ❧These drawings of trees, as well as his other detailed studies from nature, were often incorporated into larger anecdotal scenes. For example, the fantastic trunk with the splendid patterning of the bark, the leaves and the roots in *The Old Oak and*

Man Seated Beneath It [56] seems to have been used in his great drawing of the *Fortune Teller* [104]. De Gheyn also combines his interest in trees with people studied from life. The two seated figures on the left in the latter drawing are present, but now standing in a *Study of Three Gypsies* [105][30] while the fortune-teller bears a close resemblance to de Gheyn's old women who appear as separate heads observed after nature in a drawing like the Teyler *Study of Three Hags* [97]. ◦ *The Fortune Teller* [104], which combines the real and the unreal, brings us to the realm of sorcery and witch-craft which held a great fascination for de Gheyn. It gave him still another opportunity to incorporate his knowledge of science and nature with the world of the occult. Here de Gheyn illustrates the wandering sorcerers, known traditionally as Bohemians or gypsies, while on several other occasions he executed incredible studies and finished compositions of satanic sorcerers, who resided in specific villages [97–100, 108]. ◦ De Gheyn, as he demonstrated in his drawings of animals, plants and human anatomy, intently studied his subject. This was certainly the case with the lore of witchcraft.[31] Nor is it surprising, for it had been a long-established tradition for learned men interested in natural science to study sorcery and since medieval times they were often accused of practicing it. De Gheyn's study of this subject reflects both an interest in contemporary events,[32] and also, very likely, a knowledge of the descriptions and codifications of witchcraft published earlier, beginning around 1486, in a book like the *Malleus Maleficarum* and the even more detailed but later publications by Nicholas Remy in 1595 and Martin del Rio in 1599–1601. De Gheyn also was very likely familiar with sixteenth-century publications that denied the existence of witchcraft and ascribed the incredible achievements of sorcery "documented" in the aforementioned literature and other sources to the taking of drugs. This new scientific approach was inaugurated by Johann Weyer in his *Praestigiis Daemonum et Incantation ac Veneficiis* (Basel, 1568), which also marks the beginnings of modern psychiatry. Here Weyer discusses the ingredients which were known to have been used by witches in their special ointments. One type, which was a mixture of the fat of an unbaptized infant (usually present in all of these mixtures) contained such ingredients as aconite, belladonna, opium and other somniferous drugs while another, which included poppy

seeds, hemlock and belladonna, produced a state of delirium. These oint-
ments were rubbed into the pores of the body and in this way passed into the
bloodstream causing the subjects to take off on their "trips." ✎ De Gheyn's
knowledge of the subject [94–96, 101] is clear in his finished composi-
tions, which generally represent the preparation for the Sabbath, and in his
single sheets containing studies of old women [97–100] and fantastic crea-
tures [54, 106, 107] that are traditionally included in witchcraft scenes. In
several single sheets [93, 97, 98, 100], he demonstrates his study of facial
types for the main personages in his finished drawings of witches at work
[94–96, 101]. The drawings are accurately rendered studies of hags seen
from a variety of angles and drawn to illustrate a variety of emotional
states generally ascribed to witches. The tense or dreamy facial expressions
found in the Teyler [97] and Lugt [98] drawings might even suggest
that de Gheyn was using models that were under the influence of drugs.
The Lugt sheet [98], with a woman holding a reptile, might easily have
started as a study of a fisherwoman sorting eels and then in the process of
creation transfigured into a sorceress with her attribute, the python. De
Gheyn then added another old fisherwoman behind and repeated them both
in the lower middle and upper right side of the Teyler sheet [97]. These
old women, whether drawn directly after living models or imaginatively
reconstructed from a number of observed types, present us with a dramatic
vision of old age, poverty and loneliness. In fact, the stereotyped witch was,
in the majority of cases, an old peasant woman living in isolation. ✎ Witches
were not only old hags but also, according to the *Malleus Maleficarum*, young
beauties with hidden sexual desires like the infamous Delilah. De Gheyn
included such types, and when he did so, he used a special drawing style. In a
study of four beauties and an old witch [93], the young ladies are drawn in
a maniera style, reminiscent of Abraham Bloemaert, in order to impart to
them an erotic witch-like beauty. De Gheyn cleverly juxtaposes a realistic
and maniera style to achieve a carnal effect. When he renders lords and
ladies who participated in these ceremonies but cloaked themselves from
head to foot for fear of being recognized, he returns to a bold realism [102].
This sheet, in the Lugt Collection [102], further stresses de Gheyn's knowl-
edge of the variety of social types concerned with witchcraft.[33] His deep

28

demonological interests also make themselves felt in his splendid studies of the paraphernalia used in witchery. The drawings we are about to discuss reveal a first-hand knowledge of the literature of witchcraft and perhaps even attendance at a witches' session. A drawing in the Lugt Collection, Paris [106], inscribed "N° 3," must have been part of a sketchbook devoted entirely to this subject. Here de Gheyn includes two open books which seem to refer to the two volumes, sometimes combined into one, customarily used by witches to summon the good and bad spirits. These books, *La Clavicule de Salomon* and *Le Grimorie du Pape Honorius*, existed in manuscript form until the seventeenth century and were in great demand by noblemen, physicians, scholars and, of course, witches. De Gheyn's center volume is opened to a page containing an illustration of a hand which represents the "hand of glory" which was used to cast spells. This image is usually found on the mantelpiece in the preparation of the Sabbath and it is there that we shall find it in de Gheyn's Berlin drawing and against the back wall in the Oxford sheet [96, 101]. Along with the books [106], de Gheyn also includes three fantastic creatures and here he uses imaginatively his laboratory knowledge of anatomy. These three beasts are accurate composites of human and frog forms. The two on the left have female organs and long emaciated hands while the one on the right has male organs. To add to the sense of witchery, these monsters assume human poses. According to tradition, witches are normally connected with familiars or spirits that appear to them and take on fantastic shapes with incredible anatomical combinations. De Gheyn plays with such forms more than once, and we find them again, for example, in a splendid sheet in Frankfurt [54]. In the foreground a male witch reads to his fantastic familiars while in the background a female witch walks with two familiars. Still another instance of this type is the study of the single-winged spirit, part human and part fish, thumbing its nose gloriously and impishly at the world [107]. ❧ Perhaps de Gheyn's most magnificent human-animal creation is the monster in the drawing of the *Preparation for the Sabbath* in Christ Church, Oxford [94, 95]. De Gheyn's monster is an ingenious combination of a human torso and limbs with a long exaggerated duck-like neck joining with a skull that appears to be an enlarged version of the heads in his drawing of two dead pigeons [52]. The feet [94, 95], with their elong-

ated and attenuated toes, are similar to the fingers found in the Paris study of the half-frog, half-female images [106]. This grotesque creature illustrates once more the artist's ability to transmogrify anatomy in order to create a horrifying and real image of a monster from the world of sorcery. The beast, very likely the Devil himself, is carrying an equally terrifying couple who are about to set off on a journey to the Sabbath grounds. The woman is apparently a witch accompanied by her familiar or spirit. Actually this entire drawing illustrates a detailed knowledge of one very important aspect of witchcraft, the preparation for the Sabbath. The center is occupied by small animals traditionally associated with witches—the mouse, the cat and the frog. In the case of the last, de Gheyn places the animal in a position assumed for dissection that repeats the attitude of one of the frogs in the Amsterdam *Study of Frogs* [45] which was done from actual observation in the laboratory. De Gheyn also takes care to include the most important tool of witchcraft, the *Black-book*, necessary to concoct the brew. The left side of the drawing is given over to the witches who sit in and before a stone structure. Only one witch is active, and she works on her evil concoction while several others seem to be off in a dream. The dazed witch in the left foreground, with her thin skull and sunken features, is a close variant of the female head in the Teyler *Study* [97]. Another figure, seated behind the arch, appears also to be in a trance. It is not impossible that these two ladies have partaken of a brew that caused hallucinations. The woman walking through the arch and carrying a candle and a stick might be the type of demon classified by Del Rio as "*Sibyllae, seu Nymphae albae, Dominae nocturnae, Dominae bonae* with their Regina Habundia." These spirits were said to bring prosperity and abundance. The figure could also be a witch preparing to leave for the Sabbath on her broom handle and carrying a candle to light the way. De Gheyn also created a wonderful version of this subject which takes place entirely out of doors, but unfortunately the drawing is lost. The engraving after the drawing, published by Nicholaes de Clerck, contains a full complement of fantastic animals, including a lizard, which repeats the study, dated 1600 [44] and formerly part of a sketchbook. Of special interest in this engraving is the tree, which is clearly related to the trees in the studies done in Leiden and Amsterdam [56, 60]. However, now

30

the smoke rising from behind the tree trunk takes the shape of branches, deepening our sense of de Gheyn's fulgent imagination, which is always based upon nature's forms. ❧ There are two other studies of the preparation for the Sabbath but now placed in incredibly vaulted and lighted interiors. The drawing in Oxford [96], which appears to be dated 1600, reduces the number of figures to three and again shows off de Gheyn's knowledge of witchcraft and anatomy. The latter is especially evident in the body of the dissected human,[34] which, typical of anatomy demonstrations, emphasizes the cavity of the stomach and chest.[35] This stress on anatomy is repeated in the position of the frog placed just in front of the cadaver. The witches are very likely following a *Black-book* recipe which includes human as well as animal members. There are also plants and toadstools in the foreground—the latter being a most essential ingredient of the brew. The usual animals are present, such as cats, mice, bats and a hardly discernable monster's head silhouetted against the light background on the left. The skulls, bones, book, knives and hand of glory are dispersed about the scene to give the maximum dramatic effect. The wicked old hags, made even more evil when seen in profile, repeat a type that de Gheyn recorded from life in his *Study of Three Hags* [97]. In this Oxford drawing [96], he is able to capture fully the eerie atmosphere by fixing the scene in an imaginary vault-like structure and by pervading it with a light that becomes brighter as one moves back deeper into the drawing, thereby creating unbelievable silhouettes. He uses a reverse chiaroscuro which Rembrandt and his most gifted pupil, Carel Fabritius, will use so effectively later in the century. Although representations of this subject are known earlier, there is no precedent for de Gheyn's handling nor his display of the knowledge of witchcraft in the details. However, his drawing of the same subject in Berlin [101], does call upon an earlier example. This sheet, with its curious opening in the center foreground, great clouds of smoke with odd combinations of animals, people and a figure disappearing up the chimney on a broomstick, seems to be an adaptation of Pieter Bruegel's in the 1565 *St. James Visiting the Magician Hermogenes*. De Gheyn, however, changes it decidedly, and it must be seen only as a distant echo of the great master from whom de Gheyn borrowed on other occasions. ❧ In the Berlin drawing [101] of the preparation for the Sabbath, the witch in the

31

left foreground seems to be a composite of at least two drawings made by de Gheyn after life. Her head is close in type to the old hag in the *Study of Four Heads* in Haarlem [100] while the placement of the body and the distaff and spindle repeat precisely a study that de Gheyn made of a housewife found on a numbered sheet from a cut-up sketchbook [99]. The distaff and spindle are traditionally associated with the Fates, which might suggest that she holds the fate of mankind in her hands through the evil spirits that she controls. The staff itself was, according to Remy's writings published in 1595, prepared by the witch as a weapon that could kill man or beast by simply touching them. The witch is surrounded in the drawing [101] by the usual familiars and plants, especially mushrooms, and just below in the opening of the vault one finds a sleeping figure being sniffed by rodents and cats. The completely relaxed position of the sleeper indicates a state of euphoria. Just above and to the right are two very elegantly dressed women. The treatment of their bodies and their exaggerated poses add an artificial elegance to the scene which is further stressed by the contrast with the old crone ushering them in from behind while others work on the magic potion. The woman in the foreground, dressed in white and carrying a lighted candle, might very well be an allusion to the type of vision described by Del Rio as "that kind of spectres who are seen in groves and other pleasant places in the shape of girls and matrons clad in white, or sometimes in stables with lighted candles, drops of wax from which are found in combing the horses' manes." To her right one finds a partially clothed beauty carrying a head on a tray— perhaps the head of a baby which will be used in the brewing of the potion. Sprenger and Institoris, in the *Malleus Maleficarum*, discuss this kind of detail, quoting from literary and biblical sources such as Cato, Cicero, Seneca, Ecclesiastes, St. Matthew, etc. In the center of the scene the witches, one of whom reads the directions from the *Black-book*, are mixing their magic potion in the company of their familiars. One of them, who shrieks, is an elaboration of the study of a frog with an open mouth [45]. The success of the potion is evident everywhere in the drawing. In the smoke above, one witch is carried to the Sabbath riding a goat, really a transformed demon. According to one writer, Pierre de Lancre, this means of transportation was rare and reserved for special people. Still another witch takes off on a broomstick

through the chimney. Beginning with the *Malleus Maleficarum*, it was said that the broomstick was anointed with the unguent made from the limbs of children and consequently immediately rose into the air and always up the chimney. A witch never used a window or door, but the dark chimney was the normal exit when leaving for Satan's paradise, the Sabbath. Of vital interest was the placement of the broom's handle. In the sixteenth century, it was held with the head pointed downward while early in the seventeenth century, the head was held upward and often contained a lighted candle. De Gheyn here, and in one other composition,[36] follows tradition as he so often did, but, of course, he adds his own fantasy in the wonderful variety of smoke that engulfs the disappearing figure. ❧ The Berlin drawing [101] also depicts witches that appear to be in a trance and could be dreaming that they are already present at the Sabbath as in the Christ Church scene [94, 95]. This is especially evident in the three seated figures in the left background beneath the arch who seem to be clearly under the effect of the witch's potion. In front of the arch and to the right of the cauldron is a witch, also in a trance, resting on her left side. This might indicate a type described in the *Malleus Maleficarum* who did not wish to be transferred bodily to the Sabbath, but, all the same, wanted to know what was happening there. By lying down on her left side, the activities of the Sabbath would be revealed to her in a vision. This figure and those seated beneath the lighted vault in the left background suggest that they are under the influence of soporific and delirium-producing narcotics. The use and effects of drugs in witchcraft had been carefully studied and the results published in 1568 by the famous medical doctor Johann Weyer. Considering the importance of this book and de Gheyn's scientific interests, it is most likely that he knew of Weyer's pharmacological investigations and especially his discussions of the effects of belladonna, opium, marijuana, etc. ❧ As we have seen so often with de Gheyn, science and fantasy are very closely interwoven. If he was aware of Weyer's investigations and scientific explanations for the creation of spells, and I think he was, de Gheyn was equally cognizant of the magic invoked to establish such conditions. This is evident by his inclusion of the hand of glory on the mantelpiece [101], where it is generally found. This image was used to stupefy those who saw it and to make it impossible for such people to move.

The hand of glory, in de Gheyn, is usually accompanied by a lighted candle [96, 101] known as the "magic candle," which made it possible to uncover buried treasure. ✒ From all of this one can conclude that de Gheyn knew the literature of witchcraft, and I cannot help but think that his inquisitive mind might very well have encouraged him to attend at least one preparation for the Sabbath. ✒ De Gheyn's obvious knowledge of the Devil's corrupting activities on earth is coupled forcefully with a strong devotion to the principles of Christianity and a comprehension of the Bible. This manifests itself in the designs for the prints illustrating Old and New Testament themes [1-2] and allegories [5, 6, 11-13]. De Gheyn executed these engravings after his own drawings and after those by Catholic[37] and Protestant artists. On a number of occasions in the late 1590's the young liberal Protestant Hugo de Groot added Latin verses to de Gheyn's religious and allegorical prints [12], a collaboration suggesting that perhaps de Gheyn left the Catholic Church before 1600. However, this is not certain because his *St. Sebastian* [4] of ca. 1604[38] and his post 1610 *Mocking of Christ* [2] are typical Catholic subjects. When de Gheyn became a Protestant is not clear, but that he did join the Calvinist Church is evident from a short but revealing inscription on his drawing of Two Men at Prayer [5]. It reads as follows: "Simple faith and good works are more valid to God than lofty Churches." De Gheyn's only other written expression which gives us a hint of his religious feelings is even shorter and is found on a drawing dated 1625 in David Kempenaer's *Album Amicorum* [6]. Here one finds a boat being tossed about on a rough sea with storm clouds above, which very likely represents *Christ on the Sea of Galilee.* Beneath this dramatic image are two powerful words: "Fear not." The composition itself has long been associated with Salvation[39] and the text further stresses this notion but with a Calvinist overtone. Calvin, in his discussion of predestination, likens it to a dangerous sea. He writes that one finds it safe and calm unless one willfully wishes to endanger oneself. It is on the basis of these drawings and their simple inscriptions as well as the engraving representing *The Saying of Grace* that it seems probable that de Gheyn died a Calvinist on March 29, 1629.[40] ✒ In spite of the evidence that suggests de Gheyn was a Protestant, he constantly used both a Protestant and Catholic iconography. The latter is

especially evident in the very learned and complicated *Allegory of Death* [12] which he drew in 1599 in collaboration with Hugo de Groot. Here de Gheyn shows himself to be very much a part of the sixteenth century in his use of a very complex imagery to illustrate the *vanitas* theme. The scene is placed within an imaginative reconstruction of an Italian-Renaissance tomb.[41] Although the baldachin has drawn curtains and other parts of the structure display a pseudo-Renaissance vocabulary, the figures are arranged as in Northern late-medieval tomb sculpture. To be sure, de Gheyn elaborates on this traditional medieval form, but his combination of the healthy and robust with the dead and decaying is an apt variation on the "double decker" tombs known since the end of the fourteenth century.[42] This type of tomb, in which the sculptor tried to present death in its true physical form—a decomposed corpse—and life as a healthy person became normal practice after the Black Death. As early as 1362 such tombs contained inscriptions connecting them with *vanitas*. These images, with the stress upon decay, express the then prevailing notion that everyone, whether king or farmer, was equal in death. That this is precisely what de Gheyn is illustrating in the drawing and what Hugo de Groot is stressing in his text is most clear in the words inscribed at the top of the baldachin: "MORS SCEPTRA LIGONIBUS AEQUAT."[43] This and the other inscriptions by de Groot dwell on the inevitability of death and are very clever adaptations of biblical and ancient texts. De Groot seems to borrow heavily from the writings of Paul (1 Corinthinans 15:22, 45, 47), especially in the stress upon the two Adams, while reminiscences of the Old Testament (Ecclesiastes 3:20 and *passim*) are evident in the idea of decay which brings equality in death. ☙ In the upper part of the drawing, de Gheyn, continuing a long-established tradition, juxtaposes the Old and the New Dispensations. The Old, illustrated by the Fall of Man, is placed in shadow and accompanied by the owl, symbol of night, while the New, alluded to by the Crucifixion, is brightly lighted by a lamp. De Gheyn is depicting the notion of the new light of Christianity as opposed to the darkness of Judaism. This thought is further accentuated by Hugo de Groot's texts which discuss Adam's death and his defeat by the Devil as opposed to Christ's death which is seen as Adam's second death and his victory over the Devil. The presence of the skull and crossbones beneath the Adam and Eve

medallion further underlines the connection between Adam and Christ and the triumph over death by Death itself. In very early scenes of the Crucifixion, Christ was placed on a cross above the skull and crossbones of Adam.[44] To complement the skull and crossbones, which allude to the future victory over sin through Christ's sacrifice, de Gheyn places a seraph beneath the Crucifixion, symbolic of the heavenly paradise.[45] These medallions play a secondary role to the main part of the allegory which is revealed to us within the baldachin. The Last Judgment and its accompanying text, which might, in part, be based upon the Mass of the Dead, occupies the upper central portion of the composition, while just below is a winged hourglass which connects the upper and lower parts of the scene.[46] This symbol of the fleeting of time seems to have a special significance for de Gheyn. It appears again in two engravings published by Hendrick Hondius, a *Vanitas* made after a design by de Gheyn and a 1610 *Portrait of de Gheyn*, and de Gheyn's painted *Vanitas* of 1621 in the Yale University Art Gallery, New Haven, Connecticut. The winged hourglass is also found in Jacob Mathan's 1599 *Vanitas* engraving after Carel van Mander's design, but other than the aforementioned examples, all dating from around the turn of the century, the only earlier use of this motif that I know of is found in Joannis Sambucci, *Emblemata* (Antwerp, 1564), page 116. Because of the rarity of the winged hourglass and its sudden appearance in several compositions connected with de Gheyn, especially the important position it occupies in Hondius' *Portrait of de Gheyn*, it might very well be the artist's device. This emblem of "time flying" is further elaborated in the figure of the child blowing bubbles, symbolizing "HOMO BVLLA,"[47] the cadavers at his feet, and the worldly details framing and surrounding the corpses. The "HOMO BVLLA" image as a symbol of the inevitability of death was common in the sixteenth century. Five years earlier in 1594 de Gheyn's teacher, Hendrick Goltzius, made a splendid engraving entitled "QVIS EVADET?"[48] containing a muscular child, like de Gheyn's, blowing bubbles and occupying the central position.[49] Goltzius also includes a smoking vase, traditionally associated with the *vanitas* theme and very likely referring to the Book of Psalms 102:3—"For my days are consumed like smoke." This smoking vase is often accompanied by a vase of flowers, which is just what we have in the de Gheyn—lilies, roses and tulips stressing the notion of death.[50] De Gheyn

also places the worldly attributes of the prince and the farmer at the head of each corpse but in each case they are broken. The bodies themselves rest upon cut wheat, a symbol of the Great Reaper.[51] The skin is carefully reflected to reveal the muscle and bone structure while the placement of the cadavers parallel to the picture plane and in such a way that one looks down at them from above recalls the way in which the bodies are often placed in illustrations of anatomy lessons. The corpse in the lower right with the stress upon the rib cage might even be viewed as a forerunner of the type used by de Gheyn in his 1616 design for an engraving by Andries Jacobsz. Stoc[kius] of the *Anatomy of Dr. Paaw*. This subtle allusion to the anatomy lesson is appropriate in such an allegory since the whole notion of the anatomy lesson is closely connected with the *vanitas* theme. In fact, all of the anatomical theaters contained mementos reminding man that life passes quickly and that death was visited upon man through the fall of Adam. We also know that the Leiden anatomy theater served as a type of moralizing musuem. The 1609–1610 engravings of this structure by B. Dolendo[?] and W. Swanenburg after designs by J. C. Woudanus contain symbols and skeletons carrying flags with Latin texts long associated with *vanitas*. It is not by coincidence that several of the inscriptions are also present in de Gheyn's *Allegory of Death* [12]. The Swanenburg engraving of 1610, which illustrates the museum of "Kunst" and *Wunderkabinett* aspect of the anatomy theater, gives a prominent position in the right foreground to a skeleton carrying a pennant reading "MORS SCEPTRA LIGONIBVS AEQVAT."[52] Woudanus' 1609 design, which depicts an actual dissection, also includes Latin texts of a *vanitas* type, two of which are present in the de Gheyn—"MEMENTO MORI"[53] and "HOMO BVLLA."[54] This same design also contains a figure blowing bubbles and a variation on the juxtaposition of flowers and smoke that are also present in de Gheyn. One can conclude from this that de Gheyn, perhaps with the help of the young Hugo de Groot, has cleverly combined traditional motifs to create a highly original *vanitas* image much indebted to late medieval and Renaissance thought. ◆ De Gheyn's *Allegory of Death* [12] demonstrates his way of thinking in 1599. He was still working within the framework of the late sixteenth-century maniera style, preoccupied with complicated displays of knowledge. However, within a year there is a change. In his signed and

dated 1600 *Allegory of Death* [13] the theme is presented in the simple and straightforward way which will become so typical of the seventeenth century. ❧ When one considers de Gheyn's wide range of humanistic and scientific interests and his close connection with university circles in Leiden, it is surprising that he drew so few themes based upon ancient history and mythology. However, when he did, he seems to have been most partial to a subject closely related to the *vanitas* theme, that of Democritus.[55] This is obvious in a drawing in the P. & N. de Boer Foundation, Amsterdam [7] where he depicts Democritus and Heraclitus with a great globe set between them. In 1603 he uses this same configuration in his earliest known *Vanitas-Still-Life*, Private Collection, Sweden, where the two philosophers in the upper corners of the painting, as in the drawing, point and look down at a great transparent globe. While this arrangement continues, in part, a sixteenth-century iconographic form, the directness and simplicity of the drawing are evidence of an innovation of the compositional type used for the smiling Democritus and crying Heraclitus theme which was to become so popular in the Netherlands during the 1620's.[56] In the Budapest drawing de Gheyn introduces us to another episode, *The Visit of Hippocrates to Democritus*. It is here that a new subject enters Dutch art, which will be taken up by the Rembrandt Circle.[57] The Budapest drawing can also be connected with one in the Teyler Foundation, Haarlem [8], which might be the preliminary sketch for it. The young boy on the right in the Teyler drawing is almost precisely the same as the seated Hippocrates in Budapest, but the other figure and the plate placed between them make it difficult to identify the subject of this spirited sheet. De Gheyn also made two splendid drawings of Seneca [9],[58] a *Neptune* of 1610, and a marvelously imaginative finished drawing in 1605 of *Orpheus in the Underworld* [10]. Other than these and several designs for engravings, he drew very few themes from ancient history[59] and mythology. The same can be said for medieval and Renaissance subjects. ❧ There are, however, two very interesting exceptions with regard to the latter categories. Around 1600, de Gheyn made a set of engravings for Hugo de Groot's publication of the ninth century, *Codex Vossianus Latinus 79*, University Library, Leiden, which contained illustrations that were closely connected stylistically with Pompeian wall paintings.[60] De Gheyn also made a series of

38

drawings after Pisanello medals representing Italian nobles and at least one Byzantine emperor.[61] ❧ Although historical subjects from the past do not appear often in de Gheyn's drawing oeuvre, he did make a number of drawings and engravings illustrating contemporary history—especially military events. This is evident in his works illustrating and commemorating a number of important victories by the house of Nassau. De Gheyn not only illustrated sieges and battles like the 1599 *Cavalry Charge* [109], but also, beginning with his engravings of 1587 after designs by Goltzius of the *Officers and Soldiers of Emperor Rudolph II's Bodyguard*, single sheets representing a variety of military activities. Of greatest importance was the Manual of Arms for the Dutch army, commissioned by Jan van Nassau. This book, containing illustrations of the proper handling of fire-locks, guns and pikes, was first published in 1607, very likely ten years after it had been commissioned. Actually it was held back from publication for reasons of military security—until peace between Spain and The Netherlands was assured. The volume was reprinted in Dutch, French, German, English and Danish and served as the standard work for the training of armies in Europe. During these same years, around 1599, de Gheyn also executed a Manual for the Cavalry as well as single sheets representing soldiers blowing trumpets [110] which do not seem to have been included in the military instruction books. This interest in military matters might have been fostered by de Gheyn's contact with Ludolf van Collen who, in the 1590's, had been called to the newly established engineering school at the University of Leiden. De Gheyn made a portrait of this eminent engineer and swordsman in 1596, and it is also not impossible that their early acquaintanceship was responsible for de Gheyn's interest in architecture and his later efforts in this field for Prince Maurice and Prince Frederik Hendrick. ❧ Although one may stand in awe of Jacob de Gheyn II's wide knowledge and interest in a variety of subjects and his distinguished reputation in the courtly and intellectual circles of North Holland, it is, above all, his drawings that secure his fame. They make it abundantly clear that he was the most gifted Dutch draughtsman working in the early seventeenth century and was only to be surpassed later by Rembrandt.

For the documentation concerning de Gheyn and his family, the author has relied very heavily upon J. Q. van Regteren Altena, *The Drawings of Jacques de Gheyn*, Amsterdam, 1936. The following books have also been used but to a lesser extent: C. van Mander, *Het Schilder-Boeck*, Haarlem [1603-]04, fols. 293v., 295r.; D. O. Obreen, *Archief voor Nederlandsche Kunstgeschiedenis . . .* , Rotterdam, III, 1880; S. Muller Fz., *Schildersvereenigingen te Utrecht*, 1880; G. J. Hoogewerff & J. Q. van Regteren Altena, *Arnoldus Buchelius "Res pictoriae,"* The Hague, 1928; Ph. Rombouts & Th. van Lerius, *De Liggeren en andere Historische Archieven der Antwerpsche Sint Lucasgilde . . .* , Amsterdam, 1961. For de Gheyn's relationship with Hendrick Goltzius, E. K. J. Reznicek has been indispensable: *Die Zeichnungen von Hendrick Goltzius*, Utrecht, 1961.

2. For illustrations of de Gheyn's engravings and those made after his designs see F. W. H. Hollstein, *Dutch and Flemish Etchings Engravings and Woodcuts*, Amsterdam, n.d., Vols. II, VII.

3. For still another commission of this type executed by de Gheyn for Orlers see the frontispiece in the *Beschrijvinghe . . . alle de VICTORIEN . . . des Hooch-gheboren Fursti Maurits von Nassau*, Leiden, 1600 [F. W. H. Hollstein, *op. cit.*, VII, p. 149, no. 303].

4. The signed and dated picture of 1603 is in the Rijksmuseum, Amsterdam, no. 980.

5. F. Stampfle, "A Design for a Garden Grotto by Jacques de Gheyn II," *Master Drawings*, III [1965], 381ff.

6. As in the first chapter, J. Q. van Regteren Altena, *op. cit.*, is the essential reference for de Gheyn, as has been E. K. J. Reznicek, *op. cit.*, for Goltzius.

7. For de Gheyn and natural sciences see J. Q. van Regteren Altena, *op. cit.*, pp. 57, 59f., 63f., and I. Bergström, *Dutch Still-Life Painting*, translated by C. Hedstrom and G. Taylor, New York, 1956, pp. 40f., 44, 51f.

8. For information about Clusius see A. Arbor, *Herbals, Their Origin and Evolution . . .* , Cambridge, 1953, pp. 84–89.

9. Institut Néerlandais, Paris, *Catalogue, Bestiaire Hollandais . . .* , March 1–27, 1960, pp. 20f., no. 81.

10. I am especially indebted to the Misses B. E. Horner, L. Te Winkel and G. Cooper for their kind help concerning this question.

11. Cf. skeleton in the frontispiece of A. Vesalius, *De Humani Corporis Fabrica*, Basel, 1543, where the skeleton is supported by a stave held in his raised right hand. For further discussion of the ways to support a skeleton see J. B. de C. M. Saunders & C. D. O'Malley, *The Illustrations from the Works of Andreas Vesalius*, Cleveland & New York, 1950, p. 84.

12. The frog in the upper left-hand corner of the Amsterdam drawing [45] repeats the pose generally associated with a human cadaver on the dissection table.

13. For the following discussions on anatomical theaters and demonstrations, the author has consulted J. S. Held, "Rembrandt's Polish Rider," *The Art Bulletin*, XXVI [1944], 260ff.

and W. S. Heckscher, *Rembrandt's "Anatomy of Dr. Nicolaas Tulp*," New York, 1958, pp. 26, 31, 41, 132, note 45, fig. 2.

14. That de Gheyn made drawings after preserved human specimens is further attested to by the now lost drawing that he made of dead twins born only four months after the start of pregnancy. This red chalk drawing is cited in J. A. J. Barge, *De oudste Inventaris der oudste Academische Anatomie in Nederland*, Leiden-Amsterdam, 1934, p. 44. I should like to thank E. Haverkamp Begemann for bringing this to my attention.

15. G. Wolf-Heidegger & A. M. Cetto, *Die anatomische Sektion in bildlicher Darstellung*, Basel & New York, 1967, p. 309; A. Querido, "De Anatomie van de Anatomische Les," *Oud-Holland*, LXXXII [1967], 109f.

16. For a detailed discussion of this type of still life see I. Bergström, *op. cit.*, pp. 154–190.

17. I wish to thank E. Haverkamp Begemann for pointing this picture out to me in National Museum, Stockholm, *Holländska Mästare i svensk ägo*, 1967, pp. 47f., no. 53, ill. It is unlikely that the picture described by C. van Mander [*op. cit.*, fol. 294v.] as a painted skull and in the Reynier Antonissen Collection, Amsterdam, is the same as the aforementioned picture in a Swedish private collection. The picture described by van Mander must have been executed prior to 1603–1604. It may have been the earliest painted *Vanitas* but is, unfortunately, lost.

18. For the symbolic meanings of hands see C. van Mander, *Schilder-Boeck Wtbeeldinge der Figueren*, Haarlem, 1604, fol. 132v.; J. B.[ulwer], *Chirologia* . . . , London, 1644, ills. on pp. 151, 155, 189 and *passim. Idem, Chironomia* . . . , London, 1644, ills. on pp. 65, 91, 95 and *passim*.

19. It is also interesting to note that the figures in the upper right-hand corner, drawn in the old-fashioned maniera style of Abraham Bloemaert, could very well be an early idea for one of the groups in either the Berlin *Preparation for the Sabbath* [101] or a lost composition of this subject.

20. In a study in the Rijksmuseum [78] de Gheyn achieves the same impression but gives us three different figures. The quiet contemplative shepherd on the left will appear again in serious conversation with a milkmaid in the 1603 *Farmyard* [36].

21. E. K. J. Reznicek, *op. cit.*, p. 174.

22. The dates for Bloemaert's nude figure studies are difficult to establish, and I refer the reader to the forthcoming study by J. Bolten.

23. L. Münz, *Rembrandt's Etchings*, London, I, 1952, fig. 158. For other Rembrandt etchings done with a vision similar to de Gheyn's see *ibid.*, figs. 154–157, 160 and O. Benesch, *The Drawings of Rembrandt*, London, II, p. 195, figs. 205–207.

24. This is very different from Goltzius' adaptations during the same years. For illustrations of the mannered proportions in the style of Michelangelo see E. K. J. Reznicek, *op. cit.*, pp. 449f., cat. rais. nos. K 424–425, figs. 332–333.

25. The author has consulted the following authors for the landscape discussion: J. Q. van Regteren Altena, *op. cit.*, pp. 47, 53ff.; E. Haverkamp Begemann, *Willem Buytewech*,

Amsterdam, 1959, pp. 37ff.; E. K. J. Reznicek, *op. cit.*, pp. 110ff., 177, 180; W. Stechow, *Dutch Landscape Painting of the Seventeenth Century*, London, 1966, pp. 15–19, 65, 211, note 6, 102, 200, note 27.

26. In fact, one of the earliest dated de Gheyn landscapes known to me is an engraved copy, dated 1598, of Pieter Bruegel's 1561 drawing of a *Castle with Round Towers and River to Left*, Print Room, Berlin-Dahlem—see C. de Tolnay, *The Drawings of Pieter Bruegel the Elder*, London, 1952, p. 63, no. 36, pl. XIX. For the engraving by de Gheyn see F. W. H. Hollstein, *op. cit.*, VII, p. 175, no. 338.

27. For a detailed discussion of the use of this topographical motif in Flemish painting see R. A. Koch, "La Sainte-Baume in Flemish Landscape Painting of the Sixteenth Century," *Gazette des Beaux-Arts*, LXVI [1965], 273–282.

28. De Gheyn's undated *Studies of a Village, Cabbage, Peasants, etc.*, Print Room, Berlin-Dahlem [27], must also date from around 1600. J. Q. van Regteren Altena, *op. cit.*, p. 47, has connected the walking shepherd with Goltzius in his chiaroscuro woodcut of a *Landscape with a Farmhouse*—see F. W. H. Hollstein, *op. cit.*, VIII, 127, no. 380, ill. The village street in the Berlin drawing is very close to the one present in de Gheyn's *Mountain Landscape*, British Museum, London, of 1600 [28].

29. Goltzius' 1603 *Dune Landscape*, Print Room, Museum Boymans–van Beuningen, Rotterdam, shows the same debt to Bruegel but without the old-fashioned constricting trees enframing the sides that are present in de Gheyn—see E. K. J. Reznicek, *op. cit.*, cat. rais. no. K 404*, fig. 381.

30. A variation on the Chicago figures also appears in de Gheyn's engraving of a *Landscape with Gypsies*—F. W. H. Hollstein, *op. cit.*, VII, p. 143, no. 289, ill.

31. For witchcraft I have used the following books: H. Institoris & J. Sprenger, *Malleus Maleficarum*, 1489, translated by M. Summers, Bungay, Suffolk, 1928, pp. 7, 43–47, 81, 107; G. de Givry, *Witchcraft, Magic and Alchemy*, translated by J. Courtenay Locke, Boston & New York, 1931, pp. 52, 59f., 63, 65, 84f., 95–114, 180ff.; G. Zilboorg, *The Medical Man and the Witch During the Renaissance*, Baltimore, 1935, pp. 109–207; H. C. Lea, *Materials toward a History of Witchcraft*, arranged and edited by A. C. Howland, Philadelphia, I, 1939, pp. 306–347; II, pp. 505f., 604ff., 611, 640f.; G. Parrinder, *Witchcraft: European and African*, London, 1963, pp. 44ff., 60; H. Trevor-Roper, "Witches and Witchcraft," *Encounter*, XXVIII [1967], No. 5, 3–25, No. 6, 13–34.

32. Around 1590, there was an especially violent persecution of witches in Flanders and the Rhineland—see H. R. Trevor-Roper, "Witches and Witchcraft," *Encounter*, XXVIII [1967], 17–25; *Idem*, "Witches and Witchcraft [II]," *Encounter*, XXVIII [1967], 14.

33. This type appears again in the left-hand margin of the *Preparation for the Sabbath*, Christ Church, Oxford [94].

34. In general the corpse was, as in anatomy lessons, an executed criminal. The body was either roasted to cinders or boiled down to a mass and used to make magic powders and ointments according to N. Remy in his 1595 book entitled *Daemonolatreia . . .*—for

details see H. C. Lea, *op. cit.*, II, p. 611.

35. As we will find later in de Gheyn's 1616 design for Andries Jacobsz. Stoc[kius], *Anatomy of Dr Paaw at Leiden.*

36. See the engraving published by Nicolaes de Clerck illustrated in F. W. H. Hollstein, *op. cit.*, VII, p. 120, no. 96.

37. For example, Abraham Bloemaert and Cornelis van Haarlem, and de Gheyn's teacher, Hendrick Goltzius, who had strong Catholic sympathies. Whether or not Goltzius was Catholic is still a problem—see E. K. J. Reznicek, *op. cit.*, pp. 190ff.

38. The date for the *St. Sebastian* is arrived at by comparing his foreshortened head which repeats that of the sleeping boy in the lower left corner of the 1604 *Study* in Berlin [81].

39. J. R. Judson, "Marine Symbols of Salvation in the Sixteenth Century," *Essays in Memory of Karl Lehmann*, New York, 1964.

40. J. Q. van Regteren Altena, *op. cit.*, p. 40. One also finds this simple straightforward Protestant spirit in de Gheyn's *Couple at Prayer*, drawing, Print Room, Rijksmuseum, Amsterdam—illustrated in F. W. H. Hollstein, *op. cit.*, VII, p. 131, no. 114. The Old Testament spirit as applied to Calvinism is obvious in the engraving of *The Parents Visiting their Rich Children* in which the inscription begins with the words "Honor thy father and mother" [illustrated in *ibid.*, p. 130, no. 113]. It is also very likely that in 1605 deGheyn published a print by R. de Baudous which was a *Caricature on the Ceremonies of the Roman-Catholic Church* [*ibid.*, I, p. 189, no. 114; p. 191, no. 1].

41. Cf. Antonio Rossellino, *Tomb of Jacopo Cardinal of Portugal*, San Miniato, Florence.

42. E. Panofsky, *Tomb Sculpture*, edited by H. W. Janson, New York, 1964, p. 64.

43. "Death makes the scepter equal to the hoe." I wish to thank my colleague George Dimock Jr. for his generous help with the translations of these difficult Latin texts.

44. For a detailed discussion of this see W. S. Heckscher, *op. cit.*, p. 177, note 230.

45. This very same seraph will appear again in de Gheyn's painted *Vanitas*, Yale University Art Gallery, New Haven, Conn.

46. The use of the winged hourglass at this time is rare, and I have only found it in two emblem books prior to de Gheyn's—Guillaume de la Perriere Tolosain, *Le Theatre des Bons Engins . . .* , Paris, 1539, pl. LXXI; Joannis Sambucci, *Emblemata*, Antwerp, 1564, p. 116, "In morta vita."

47. "Man is a bubble."

48. "Who shall escape it?"

49. For a discussion of this see E. de Jongh, *Zinne-en minnebeelden in de schilderkunst van de zeventiende eeuw*, Nederlandse Stichting Openbaar Kunstbezit en Openbaar Kunstbezit in Vlaanderen, 1967, pp. 81f., fig. 69; and F. W. H. Hollstein, *op. cit.*, VIII, p. 23.

50. See I. Bergström, *op. cit.*, p. 155, for Old Testament passages concerning flowers and death.

51. For wheat as the symbol of Resurrection see R. Wittkower, "Death and Resurrection in

a Picture by Marten de Vos," *Miscellanea Leo van Puyvelde*, 1949, pp. 117–123.

52. "Death makes the scepter equal to the hoe."

53. "Think on death."

54. "Man is a bubble."

55. For the connection between the Democritus-Heraclitus theme and *vanitas* see L. Möller in *Reallexikon zur Deutsches Kunstgeschichte*, Stuttgart, III, 1954, pp. 1244–1251.

56. See B. Nicolson, *Hendrick Terbrugghen*, London, 1958, p. 45f. and for a detailed discussion of the Democritus and Heraclitus theme see A. Blankert, "Heraclitus en Democritus in het bijzonder in de Nederlandse Kunst van de 17de eeuw," *Nederlands Kunsthistorisch Jaarboek*, XVIII [1967], 1–124.

57. J. Q. van Regteren Altena, *op. cit.*, p. 43; T. Gerszi, "Deux Feuilles d'étude de Jacques de Gheyn," *Bulletin du Musée Hongrois des Beaux-Arts*, No. 25, 1964, pp. 84f.

58. The drawing in the Print Room, Cologne, is composed in a way very similar to Rubens —see J. Q. van Regteren Altena, *op. cit.*, p. 43.

59. De Gheyn did make designs for twelve plates illustrating the history of the Greeks which were engraved by Z. Dolendo [F. W. H. Hollstein, *op. cit.*, V, 263, nos. 48–59]. The latter also executed a series of engravings after de Gheyn's designs representing *Actions by Virtuous Women of Ancient History* [*ibid.*, p. 263, nos. 60–67].

60. E. Panofsky, *Renaissance and Renascences in Western Art*, Stockholm-Uppsala, 1960, p. 49.

61. They were also engraved by de Gheyn and it is very likely that he owned these medals— see F. W. H. Hollstein, *op. cit.*, VII, pp. 165–169, nos. 322a–326, ill.

THE PLATES

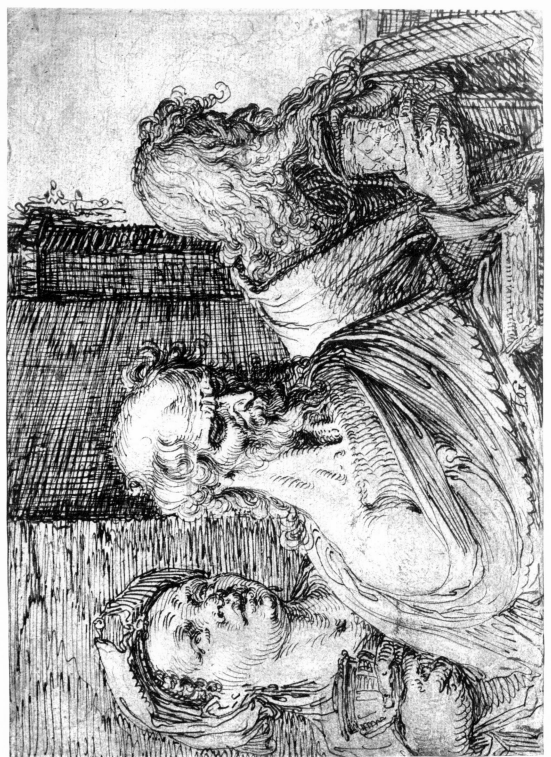

I. THE THREE KINGS, PRINT ROOM, MUSEUM BOYMANS–VAN BEUNINGEN, ROTTERDAM. PEN, INK WITH WHITE HIGHLIGHTS OVER BLACK CHALK: 141 × 189 MM.

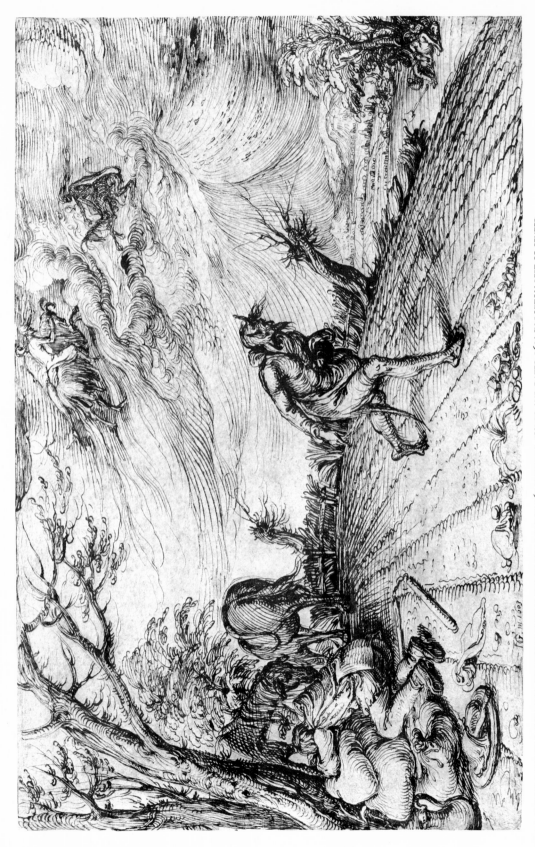

IA. SOWING OF TARES, PRINT ROOM, STAATLICHE MUSEEN, BERLIN. PEN AND INK: 263 × 417 MM., SIGNED AND DATED 1603 IN BOTTOM LEFT OF CENTER.

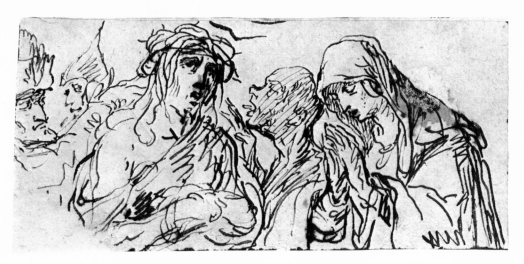

2. MOCKING OF CHRIST, COLLECTION DE GREZ, ROYAL MUSEUM, BRUSSELS. PEN AND INK: 63 × 136 MM.

3. SAINT MATTHEW, PRINT ROOM, MUSEUM BOYMANS—VAN BEUNINGEN, ROTTERDAM. PEN, INK AND WASH, OVAL: 139 MM. DIAMETER.

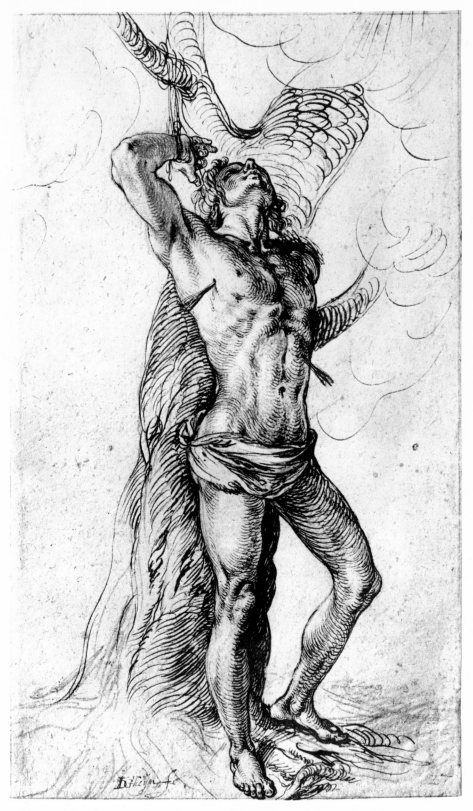

4. SAINT SEBASTIAN, SCHLOSSMUSEUM, WEIMAR. PEN, INK, BLACK CHALK WITH WHITE CHALK HIGHLIGHTS ON GREY PAPER: 385 × 232 MM., SIGNED BOTTOM LEFT OF CENTER.

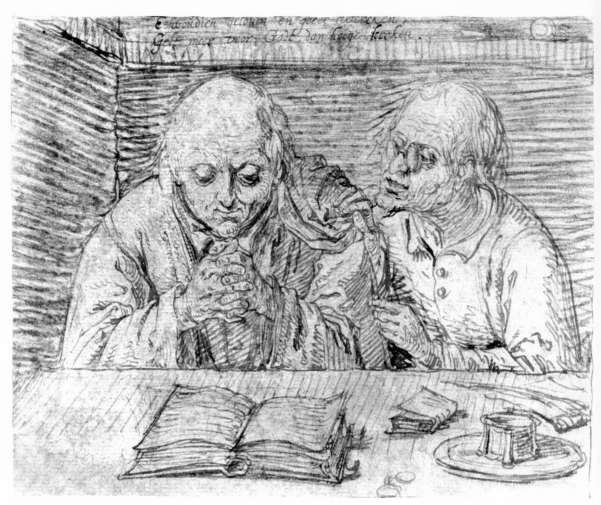

5. A MAN AT PRAYER AND ANOTHER TOUCHING HIS SHOULDER, PRINT ROOM, STAATLICHE MUSEEN, BERLIN. PEN, BROWN AND BLACK CHALK ON GREY TINTED PAPER: 130 × 162 MM.

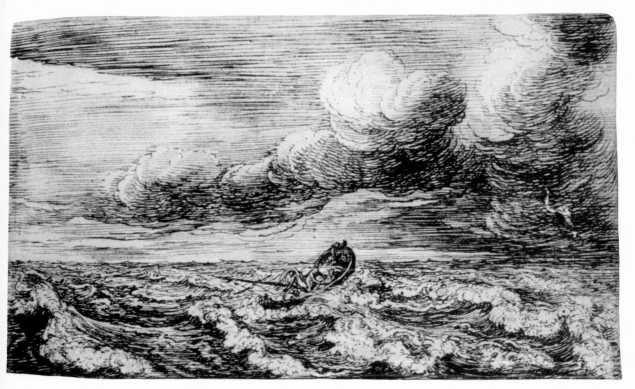

6. CHRIST AND HIS DISCIPLES IN A BOAT ON A STORMY SEA, ALBUM AMICORUM OF DANIEL KEMPENAER, FOL. 205, COLLECTION W. J. A. DE KEMPENAER, THE HAGUE. PEN AND INK, SIGNED BOTTOM LEFT WITH MONOGRAM AND BOTTOM RIGHT DATED 1625.

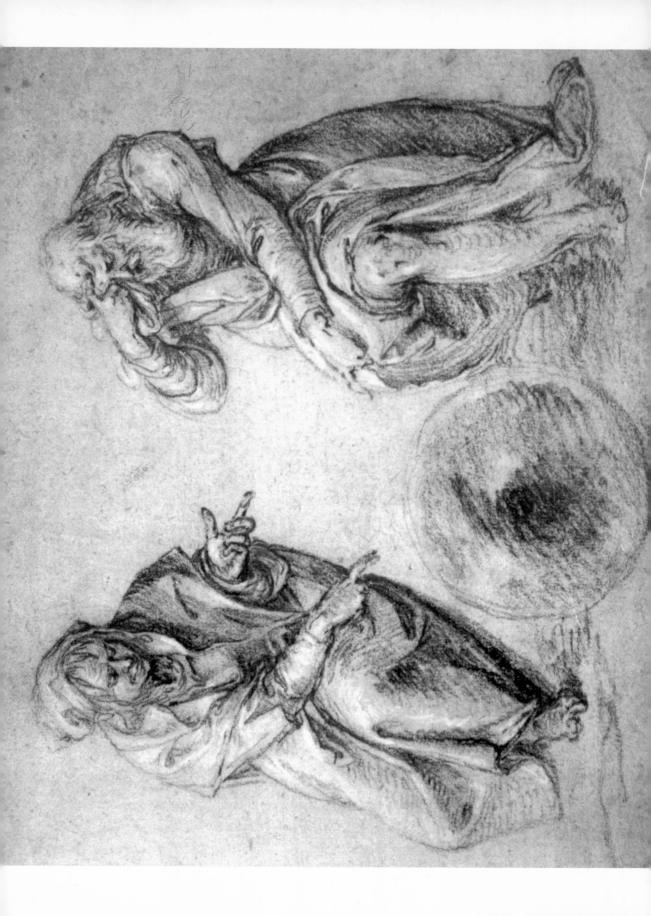

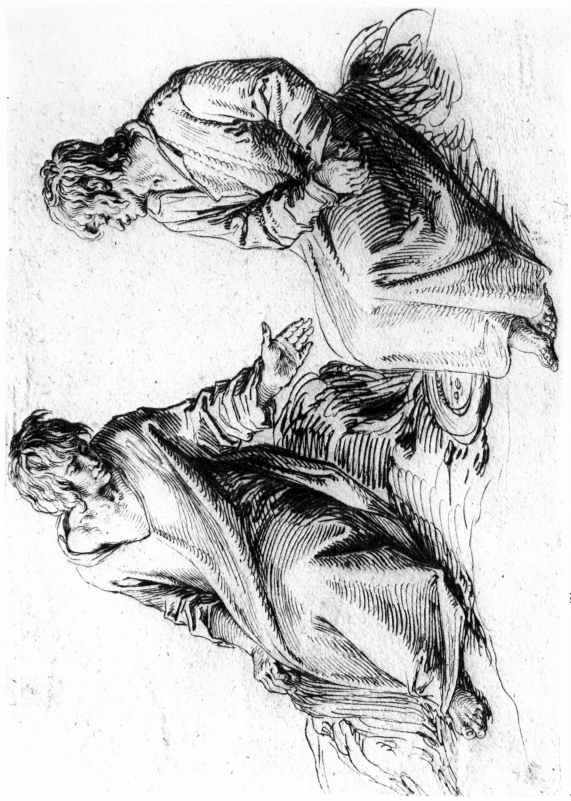

8. THE VISIT OF HIPPOCRATES TO DEMOCRITUS[?], TEYLER FOUNDATION, HAARLEM. PEN, INK, CHARCOAL IN SPOTS ON GREY PAPER: 204 × 283 MM.

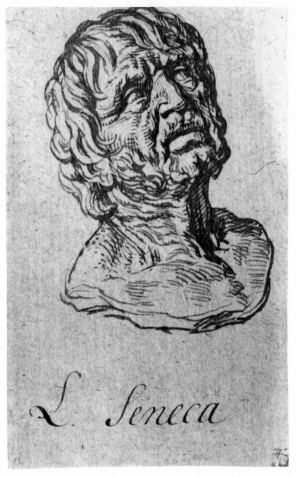

9. BUST OF SENECA, PRINT ROOM, MUSEUM BOYMANS–VAN BEUNINGEN,
ROTTERDAM. PEN, INK ON GREY PAPER: 122 × 70 MM.

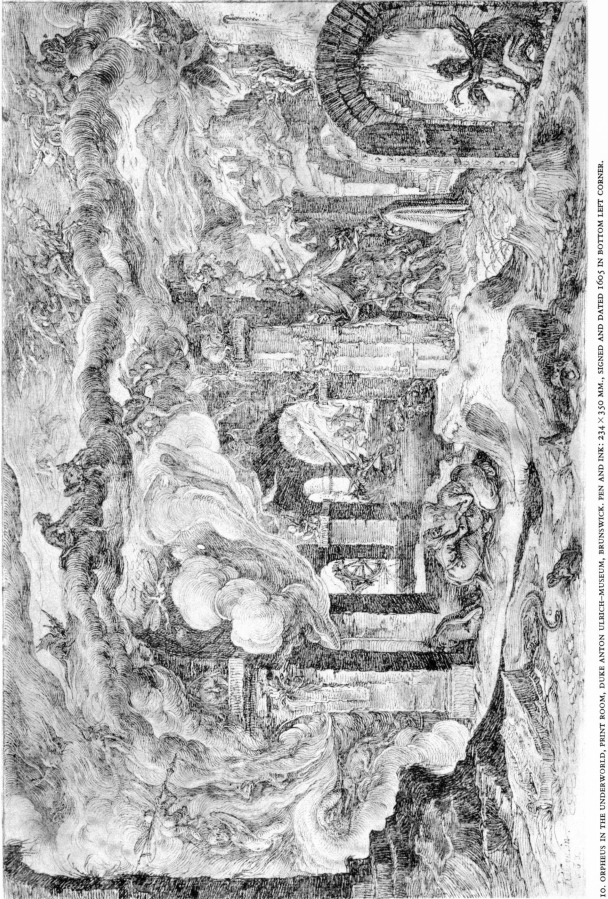

10. ORPHEUS IN THE UNDERWORLD, PRINT ROOM, DUKE ANTON ULRICH-MUSEUM, BRUNSWICK. PEN AND INK: 234 × 350 MM., SIGNED AND DATED 1605 IN BOTTOM LEFT CORNER.

11. ALLEGORY OF WEALTH, PRINT ROOM, UNIVERSITY OF LEIDEN, LEIDEN. PEN, INK, GREY AND BLUE WASH: 214 × 164 MM., SIGNED BOTTOM RIGHT CORNER.

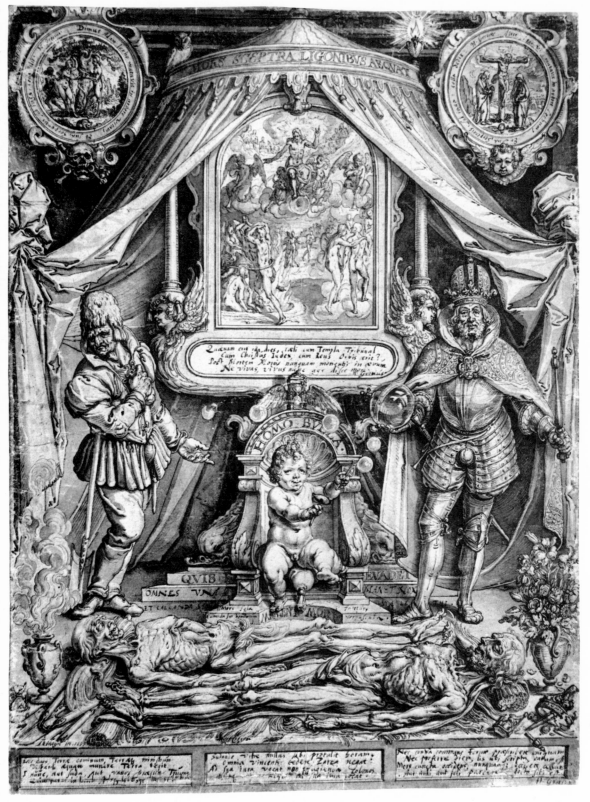

12. ALLEGORY OF DEATH, PRINT ROOM, BRITISH MUSEUM, LONDON. PEN, INK, GREY AND BROWN WASH: 457×349 MM., SIGNED AND DATED 1599 IN BOTTOM LEFT CORNER.

13. ALLEGORY OF DEATH, PRINT ROOM, RIJKSMUSEUM, AMSTERDAM. PEN, INK ON GREY PAPER: 160 × 133 MM., SIGNED AND
DATED 1600 IN BOTTOM RIGHT CORNER.

14. PORTRAIT OF TYCHO BRAHE, PRINT ROOM, ROYAL MUSEUM, COPENHAGEN.
PEN, INK, RED CHALK: 122 × 91 MM.

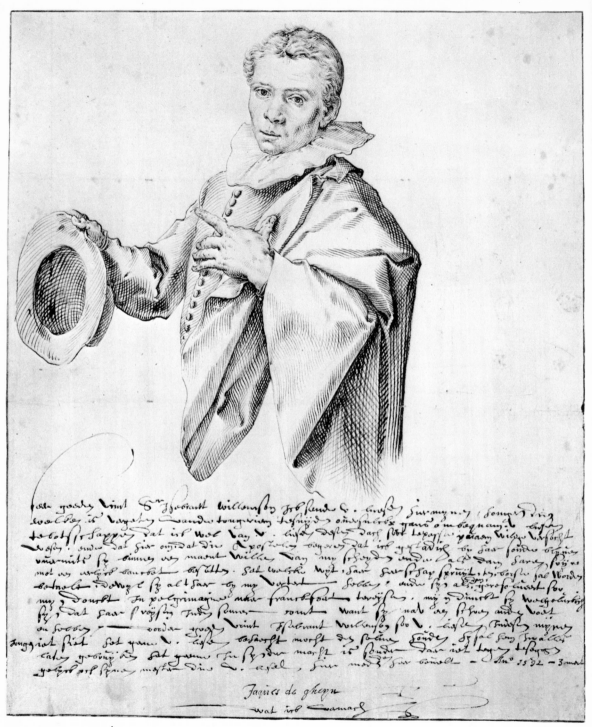

15. PORTRAIT OF DE GHEYN'S DUMB PUPIL, PRINT ROOM, STAATLICHE MUSEEN, BERLIN. PEN AND INK: 272 × 228 MM., SIGNED BOTTOM CENTER.

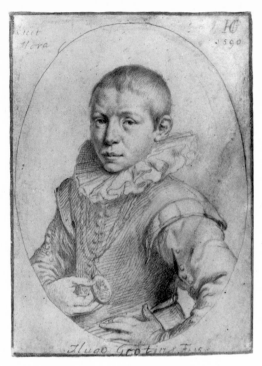

17. PORTRAIT OF HUGO DE GROOT. GEMEENTE MUSEUM,
COLLECTION FODOR, AMSTERDAM. SILVER-POINT ON
YELLOW VELLUM: 89 × 67 MM., MONOGRAM UPPER
RIGHT CORNER AND DATED 1596.

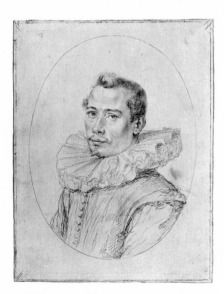

16. PORTRAIT OF HUGO DE GROOT'S BROTHER,
PRINT ROOM, RIJKSMUSEUM, AMSTERDAM.
SILVER-POINT ON VELLUM: 74 × 57 MM.

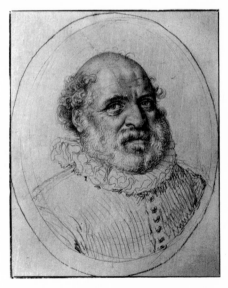

18. PORTRAIT OF RUTGAERT JANSZ. VAN D. . . . ,
TEYLER FOUNDATION, HAARLEM. SILVER-
POINT ON VELLUM: 72 × 57 MM.

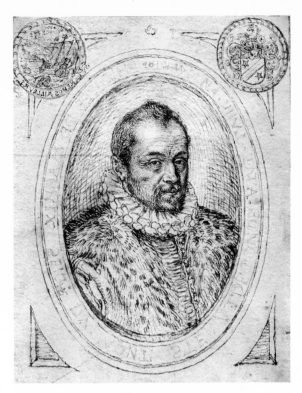

19. PORTRAIT OF PHILIP MARNIX VAN SINT ALDEGONDE, GEMEENTE
MUSEUM, COLLECTION FODOR, AMSTERDAM. PEN, INK, PENCIL:
96 × 77 MM.

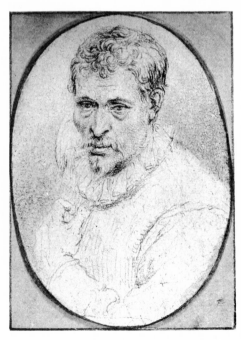

20. PORTRAIT OF A MAN [JAN BRUEGEL?],
DUTCH INSTITUTE, COLLECTION F. LUGT, PARIS.
BLACK CHALK: 88 × 64 MM.

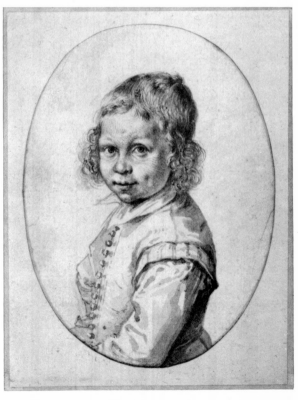

21. PORTRAIT OF A YOUNG BOY, PRINT ROOM, RIJKSMUSEUM, AMSTERDAM.
WATERCOLOR, PEN, INK AND GREY WASH: 100 × 75 MM.

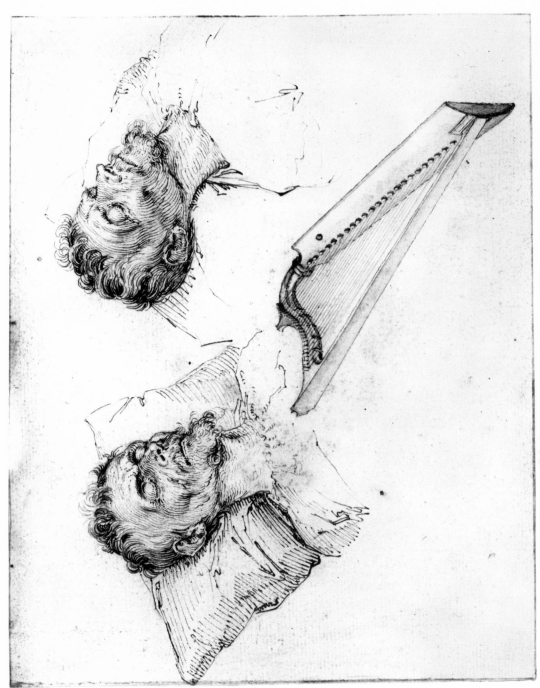

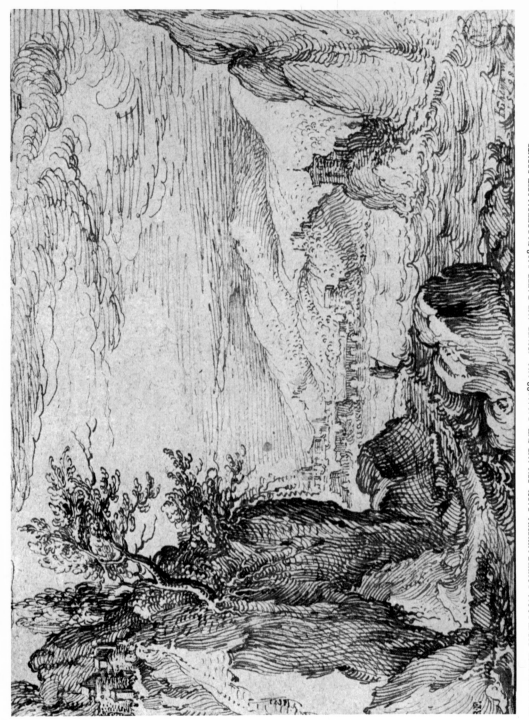

23. LANDSCAPE, PRINT ROOM, LOUVRE MUSEUM, PARIS. PEN AND INK: 140 × 188 MM., SIGNED AND DATED 1598 IN BOTTOM LEFT CORNER.

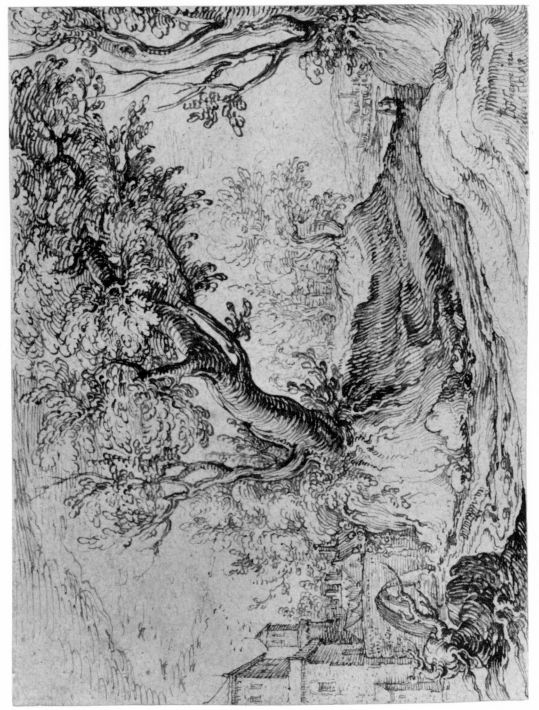

24 LANDSCAPE, PRINT ROOM, STAATLICHE MUSEEN, BERLIN. PEN AND INK: 143 × 187MM., SIGNED AND DATED 1598 IN BOTTOM LEFT CORNER.

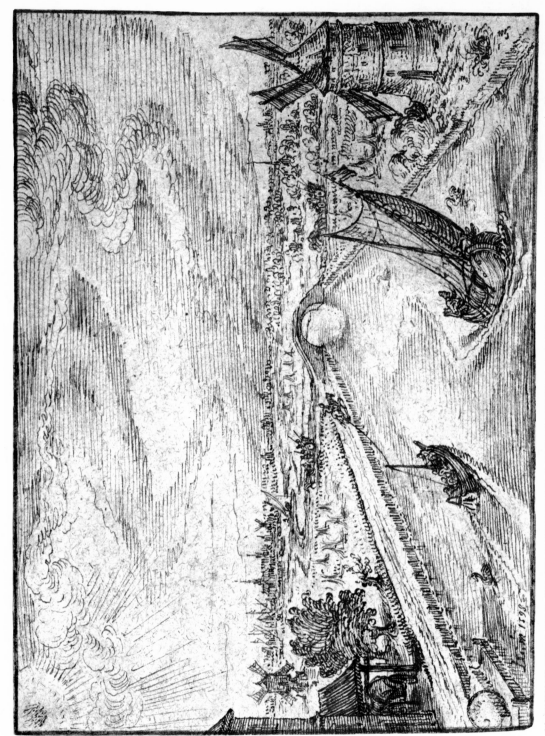

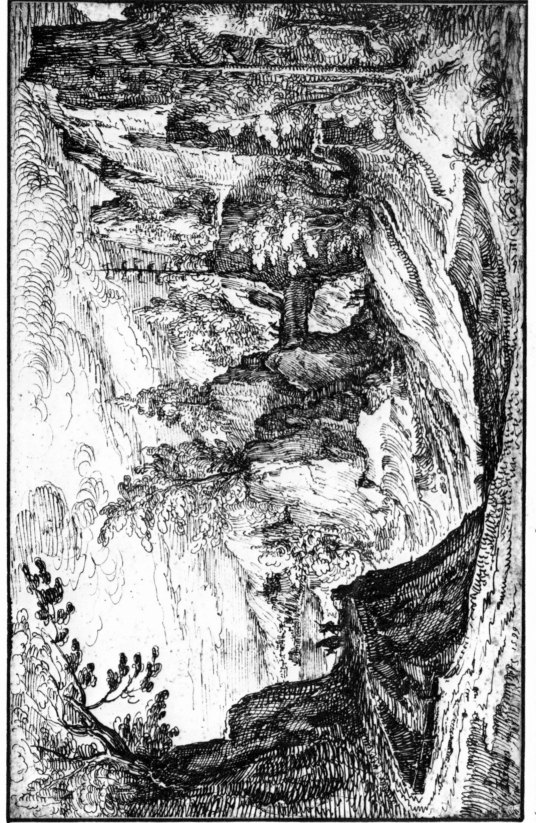

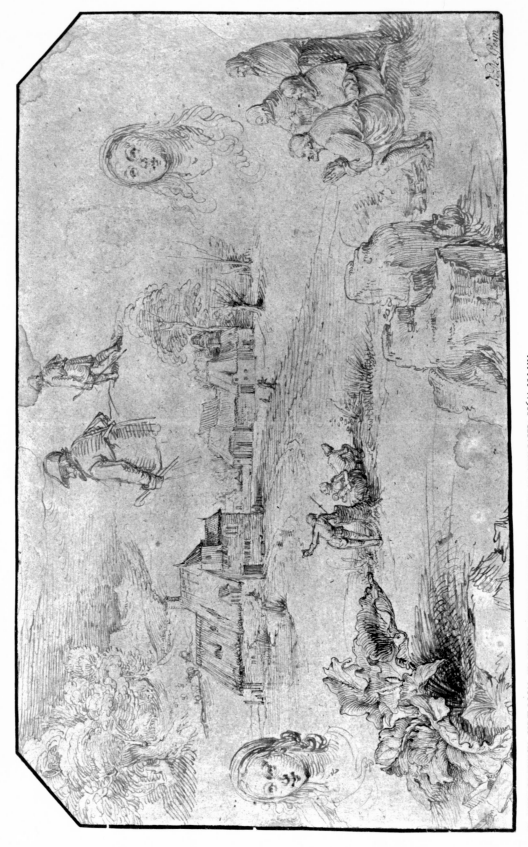

27. SHEET OF STUDIES, PRINT ROOM, STAATLICHE MUSEEN, BERLIN. PEN AND INK ON GREY PAPER: 196 × 315 MM.

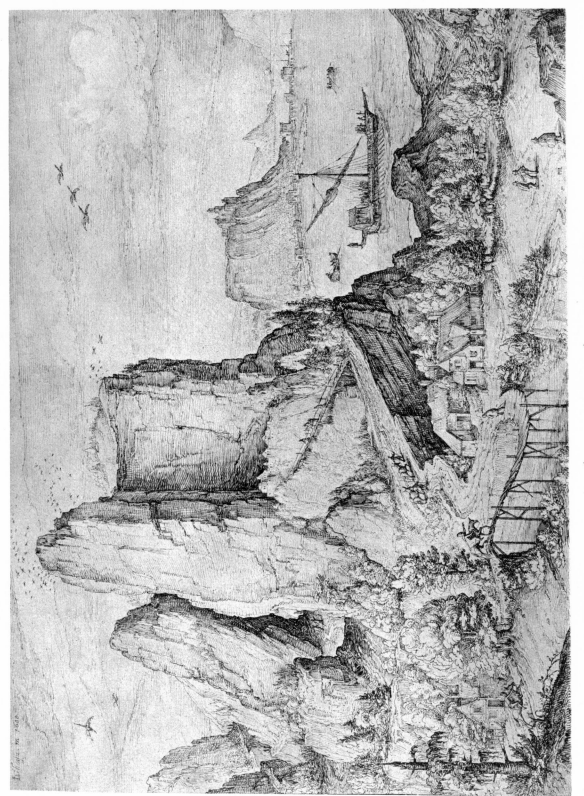

28. LANDSCAPE, PRINT ROOM, BRITISH MUSEUM, LONDON. PEN AND INK: 309 × 416 MM., SIGNED AND DATED 1600 IN UPPER LEFT CORNER.

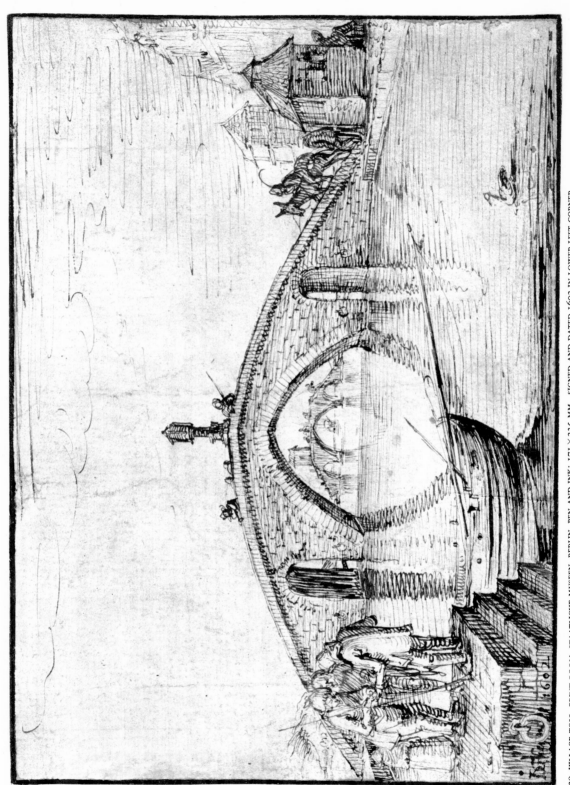

29. VILLAGE TOLL, PRINT ROOM, STAATLICHE MUSEEN, BERLIN. PEN AND INK: 171 × 235 MM., SIGNED AND DATED 1602 IN LOWER LEFT CORNER.

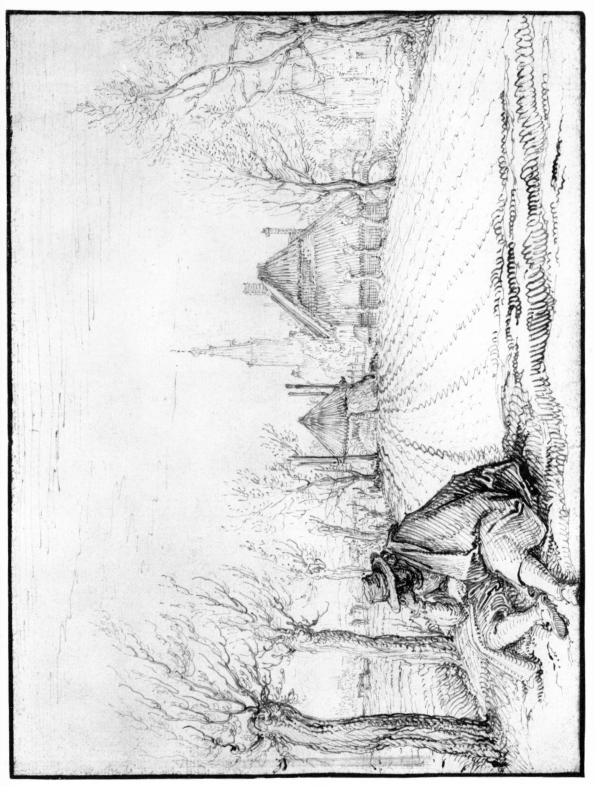

30. MAN RESTING IN A FIELD, PRINT ROOM, STAATLICHE MUSEEN, BERLIN. PEN AND INK: 156×202 MM.

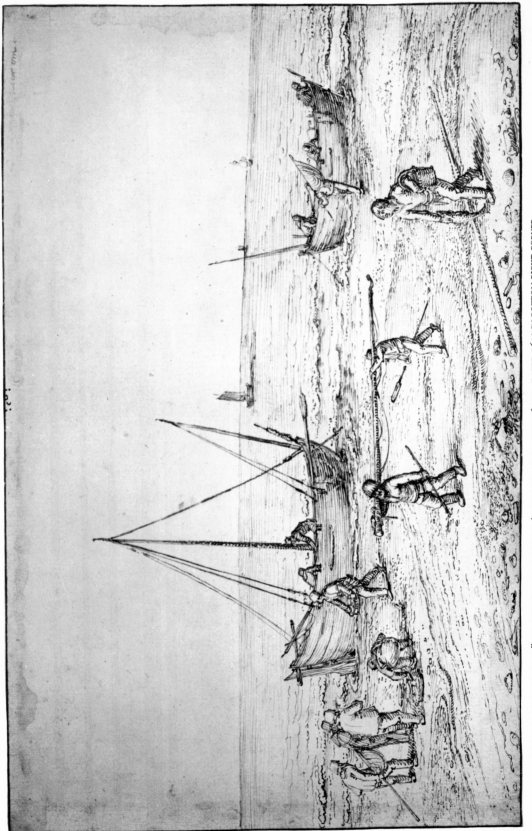

31. STUDY FOR SAILING CAR, PRINT ROOM, STÄDEL INSTITUTE, FRANKFURT A./M. PEN AND INK: 199 × 306 MM., DATED 1602 IN BOTTOM RIGHT CORNER.

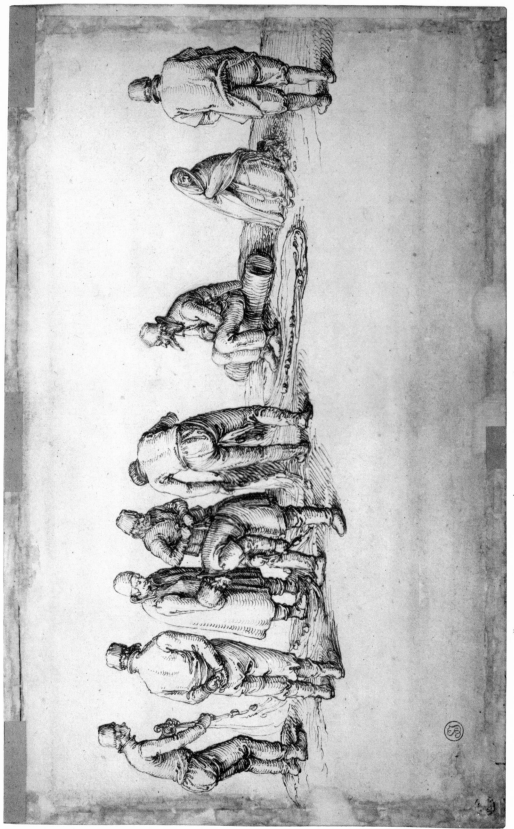

32. STUDY FOR SAILING CAR, PRINT ROOM, STÄDEL INSTITUTE, FRANKFURT A./M. PEN AND INK: 194 × 306 MM, VERSO OF FIG. 31.

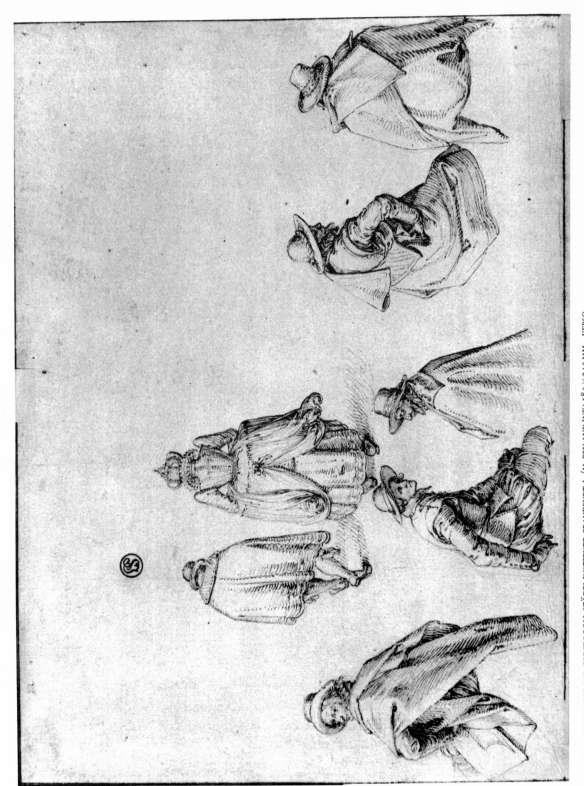

33 . STUDY FOR SAILING CAR, PRINT ROOM, STÄDEL INSTITUTE, FRANKFURT A./M. PEN AND INK: 185 × 245 MM. VERSO.

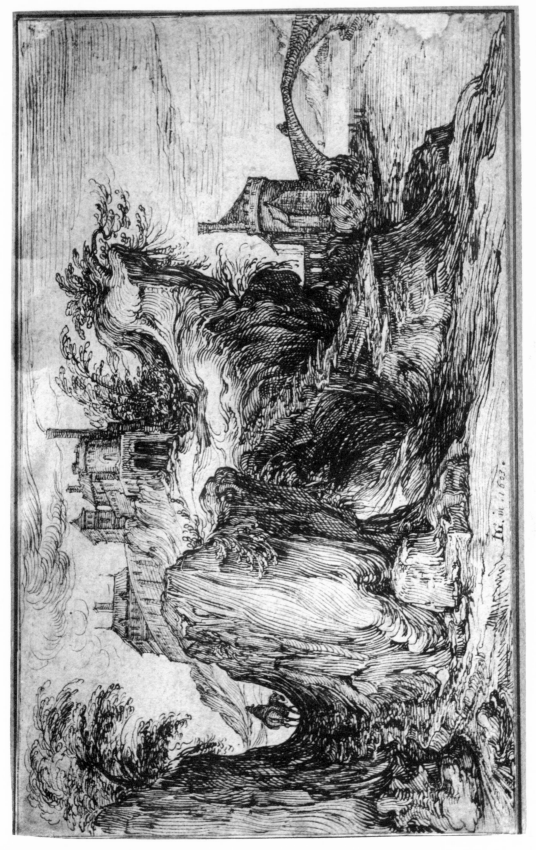

34. MOUNTAIN LANDSCAPE, COLLECTION PROFESSOR J. Q. VAN REGTEREN ALTENA, AMSTERDAM. PEN, INK AND WASH: 167 × 273 MM., MONOGRAMMED AND DATED 1603 IN BOTTOM LEFT OF CENTER.

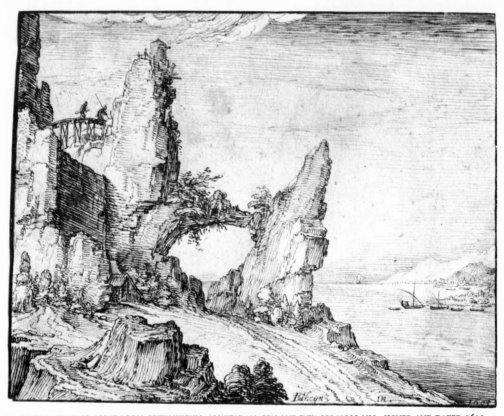

35. RIVER LANDSCAPE, PRINT ROOM, RIJKSMUSEUM, AMSTERDAM. PEN AND INK: 120 × 133 MM., SIGNED AND DATED 1603
BOTTOM RIGHT.

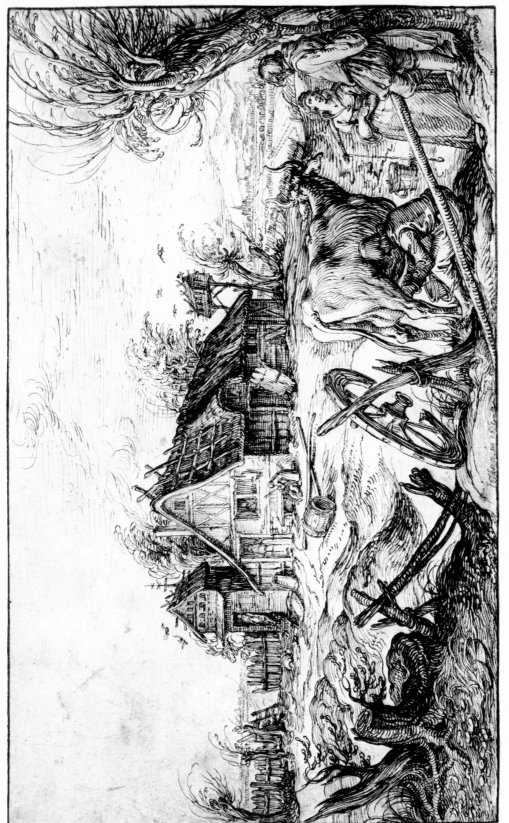

36. FARMYARD SCENE, PRINT ROOM, RIJKSMUSEUM, AMSTERDAM. PEN, INK AND BROWN WASH: 195 × 312 MM., SIGNED AND DATED 1663 IN BOTTOM CENTER.

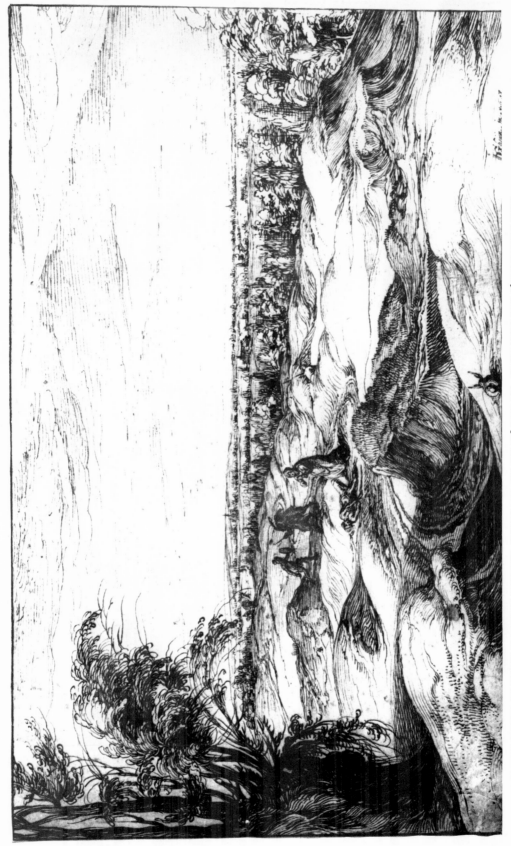

37. LANDSCAPE WITH ROBBERS, STAATLICHE GRAPHISCHE SAMMLUNG, MUNICH. PEN AND INK: 238 × 390 MM., SIGNED AND DATED 1603 IN BOTTOM RIGHT.

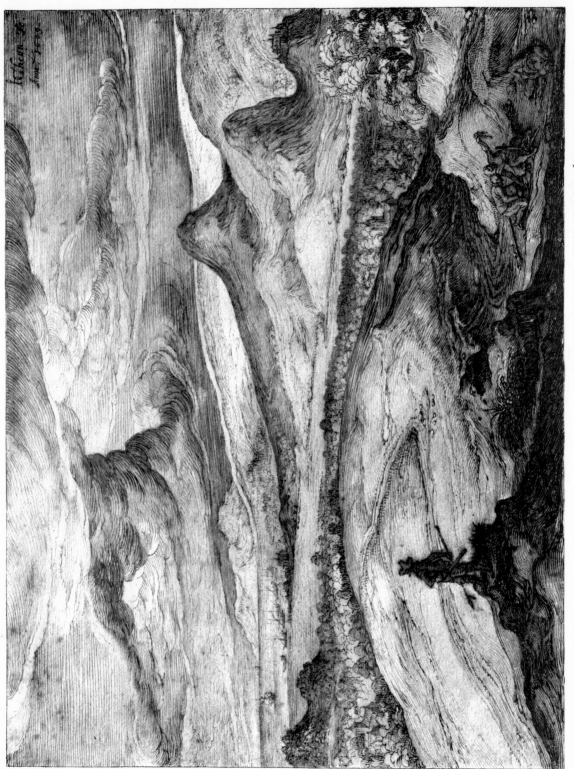

40. LANDSCAPE WITH ROBBERS, PRINT ROOM, VICTORIA & ALBERT MUSEUM, LONDON. PEN, INK AND WASH: 177 × 237 MM., SIGNED AND DATED 1609 IN UPPER RIGHT CORNER.

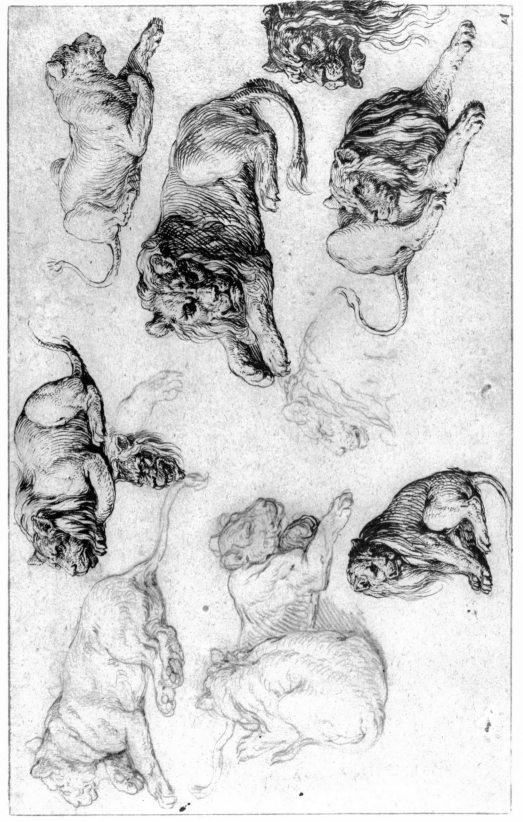

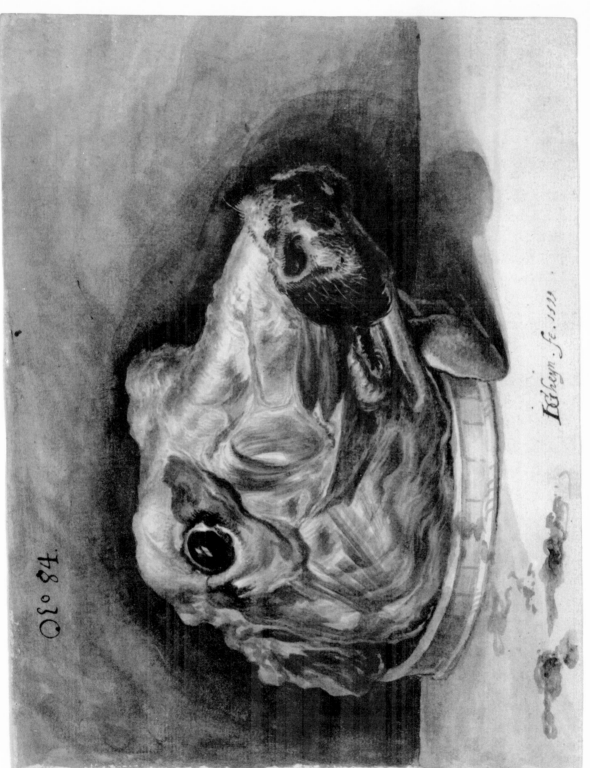

42. HEAD OF A SKINNED OX, AMSTERDAM. PEN, INK, GREY WASH, RED AND BLACK WATERCOLOR: 156 × 202 MM., SIGNED AND DATED 1599 IN BOTTOM

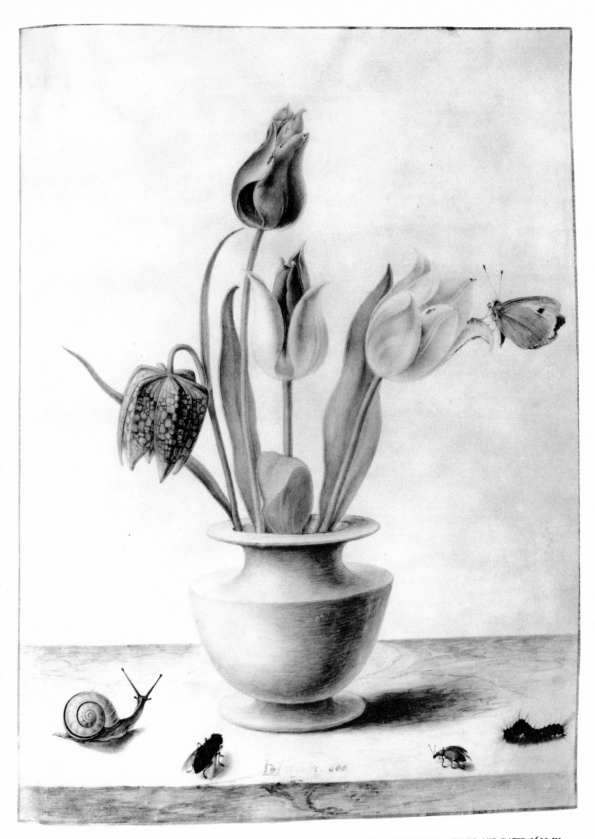

43. STILL LIFE, DUTCH INSTITUTE, COLLECTION F. LUGT, PARIS. WATERCOLOR ON VELLUM: 225 × 174 MM., SIGNED AND DATED 1600 IN BOTTOM CENTER.

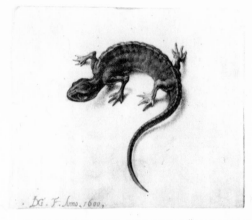

44. LIZARD OR SALAMANDER, PRINT ROOM, STÄDEL INSTITUTE,
FRANKFURT A./M. PEN, INK AND WATERCOLOR ON VELLUM:
55 × 64 MM., MONOGRAMMED AND DATED 1600 IN
BOTTOM LEFT.

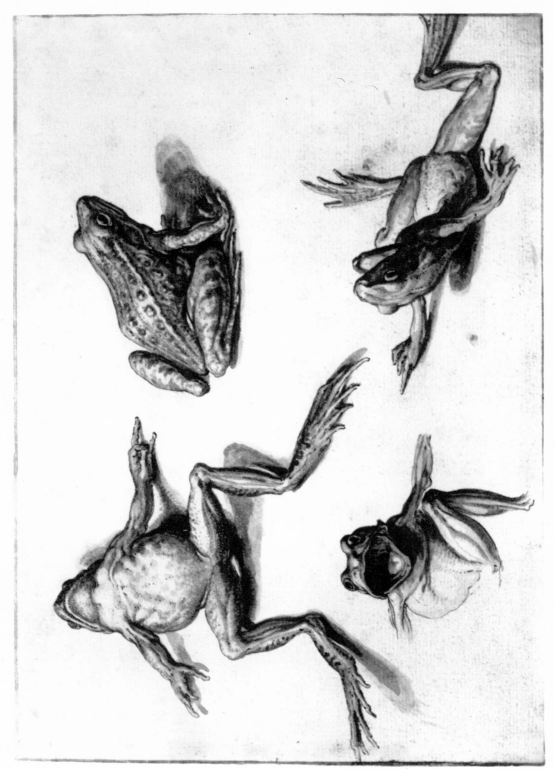

45. FROGS, PRINT ROOM, RIJKSMUSEUM, AMSTERDAM. PEN, INK, GREY WASH AND WATERCOLOR: 144 × 196 MM.

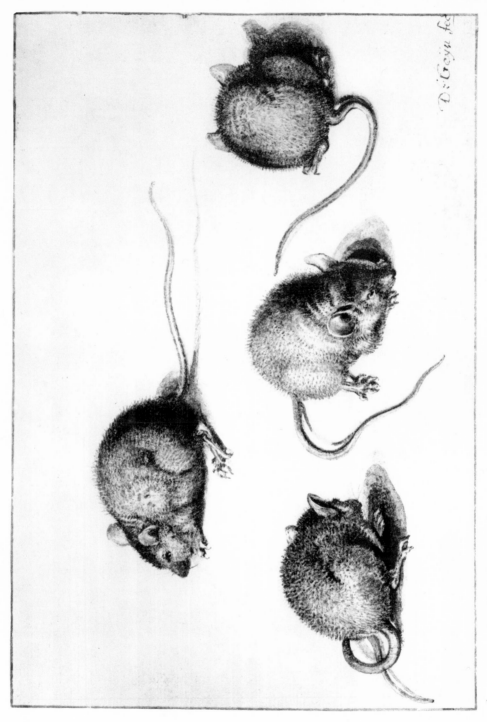

46. MICE, PRINT ROOM, RIJKSMUSEUM, AMSTERDAM. PEN, INK AND GREY WASH WITH WATERCOLOR: 128 × 183 MM.

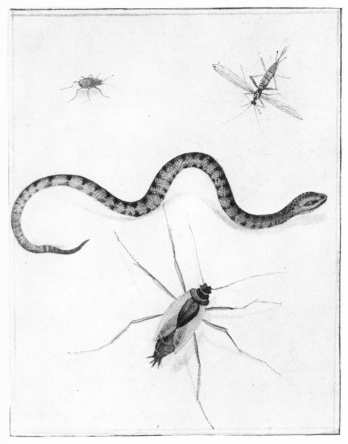

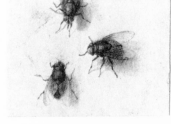

48. FLIES, PRINT ROOM, STÄDEL INSTITUTE, FRANKFURT A./M. PEN, INK AND WASH: 41 × 46 MM.

47. STUDY OF FLIES AND SNAKE, PRINT ROOM, STÄDEL INSTITUTE, FRANKFURT A./M. PEN, INK AND WATERCOLOR: 113 × 89 MM.

49. STUDY OF TWO TURTLES AND HEAD OF A CAT, PRINTROOM, STÄDEL INSTITUTE, FRANKFURT A./M. PEN, INK, BROWN WASH AND BLACK CHALK 87 × 168 MM.

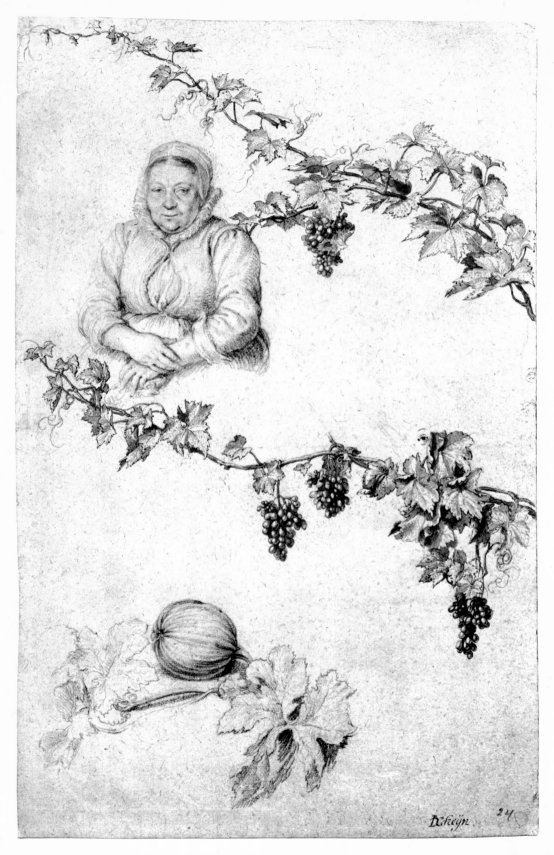

50. STUDY OF GRAPES, PUMPKIN OR SQUASH AND PORTRAIT OF A WOMAN, PRINT ROOM, STAATLICHE MUSEEN, BERLIN. PEN, INK,
BLACK AND RED CHALK: 404 × 263 MM.

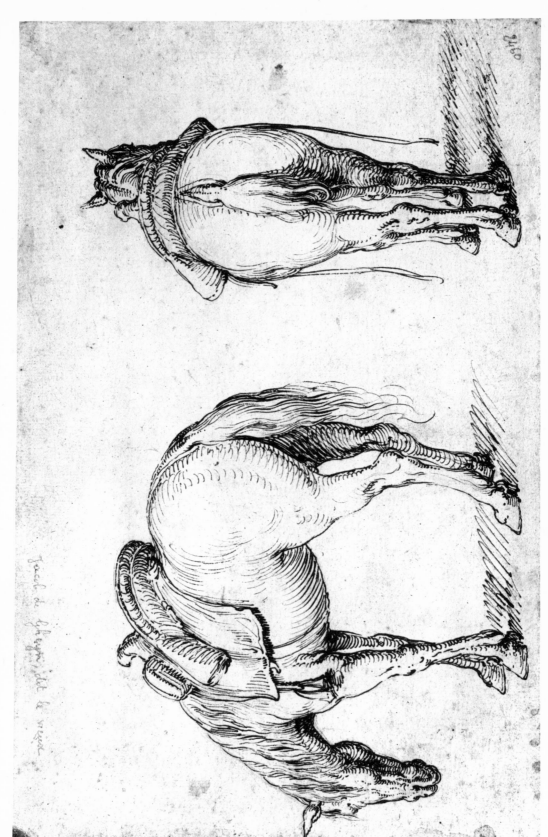

51. TWO HORSES, PRINT ROOM, ECOLE DES BEAUX-ARTS, PARIS. PEN AND INK: 188 × 277 MM.

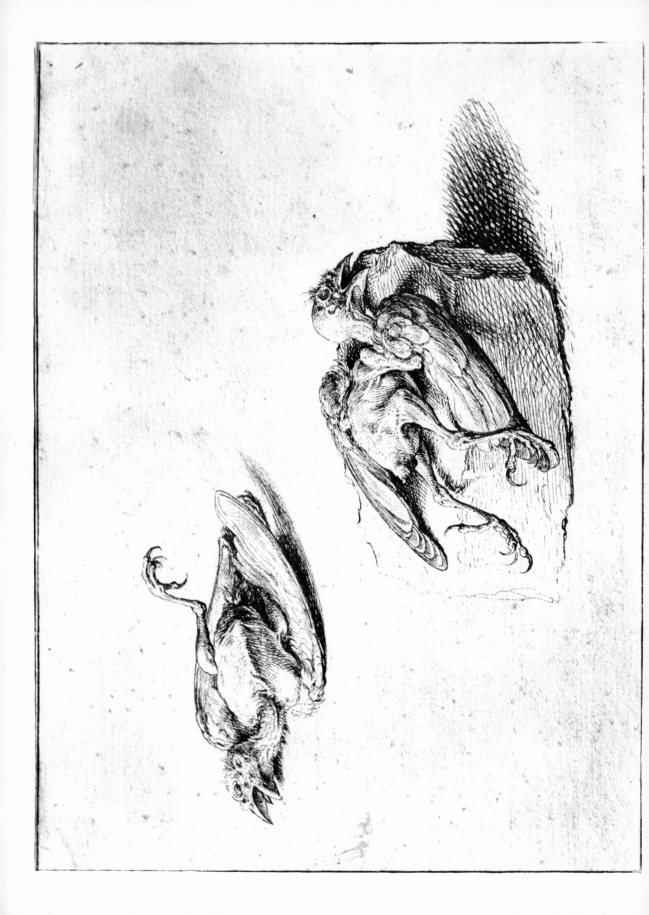

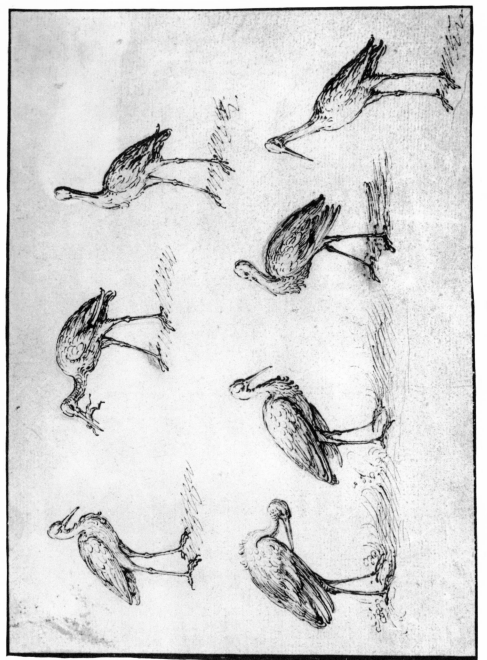

53. STUDY OF STORKS, DUTCH INSTITUTE, COLLECTION F. LUGT, PARIS. PEN AND INK: 126 × 172 MM.

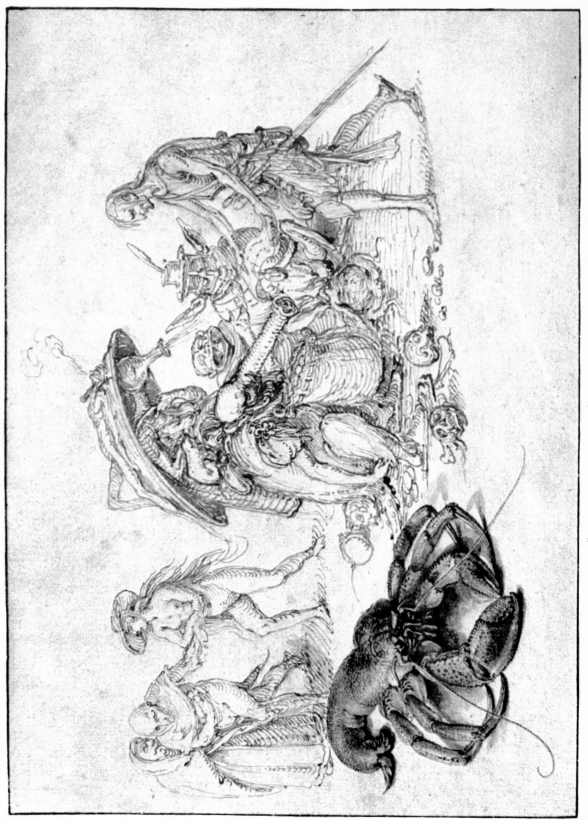

54. STUDY OF HERMIT CRAB AND WITCHCRAFT, PRINT ROOM, STÄDEL INSTITUTE, FRANKFURT A./M. PEN, INK AND WATERCOLOR: 185×245 MM.

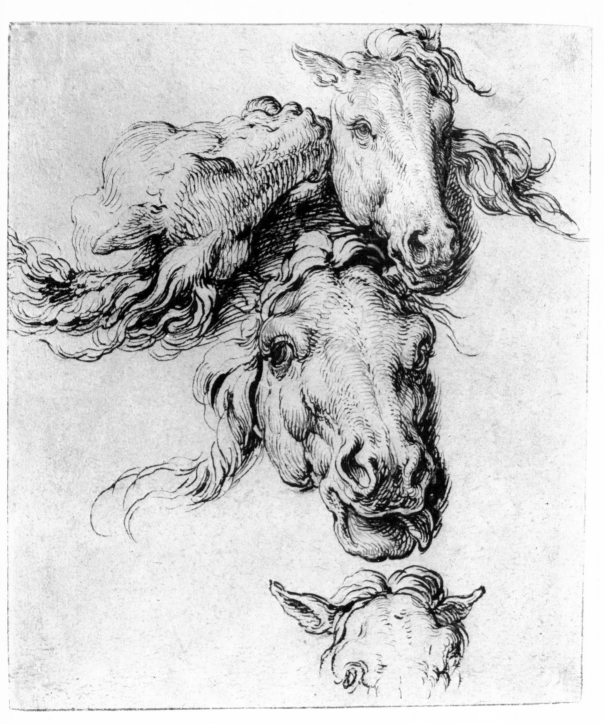

55. STUDY OF FOUR HEADS, PRINT ROOM, STAATLICHE MUSEEN, BERLIN. PEN AND INK: 250 × 215 MM.

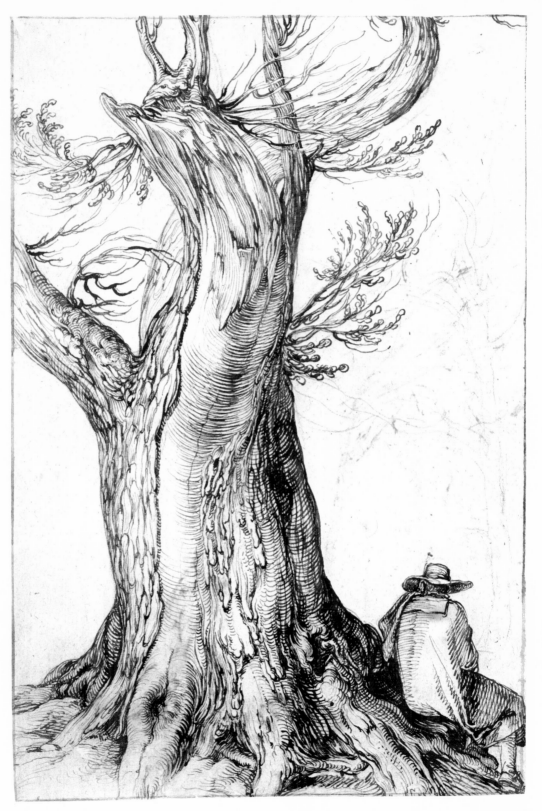

56. AN OLD OAK TREE AND MAN SEATED BENEATH IT, PRINT ROOM, RIJKSMUSEUM, AMSTERDAM. PEN, INK AND BLACK CHALK: 365×252 MM.

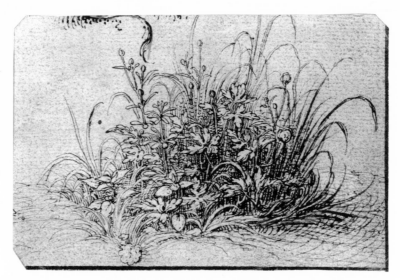

57. CLUMP OF GRASS WITH FLOWERS, PRINT ROOM, UNIVERSITY OF LEIDEN, LEIDEN. PEN
AND INK: 67 × 102 MM.

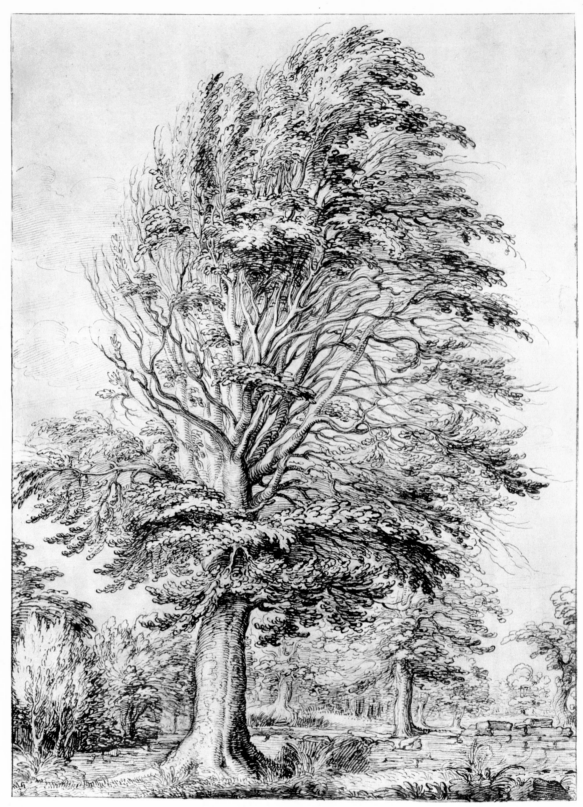

58. STUDY OF TREES, PRINT ROOM, RIJKSMUSEUM, AMSTERDAM. PEN AND INK ON GREY PAPER: 269 × 208 MM.

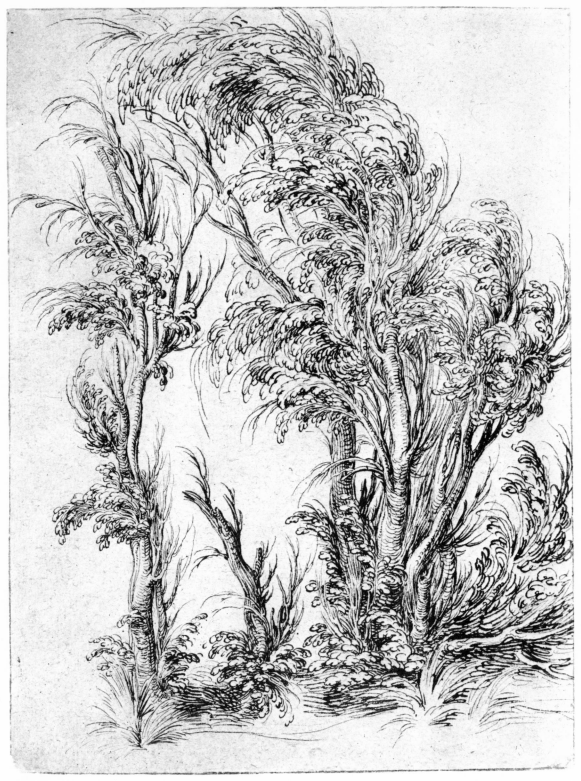

59. GROUP OF TREES, COLLECTION PROFESSOR J. Q. VAN REGTEREN ALTENA, AMSTERDAM. PEN AND WASH OVER BLACK CHALK: 350 × 257 MM.

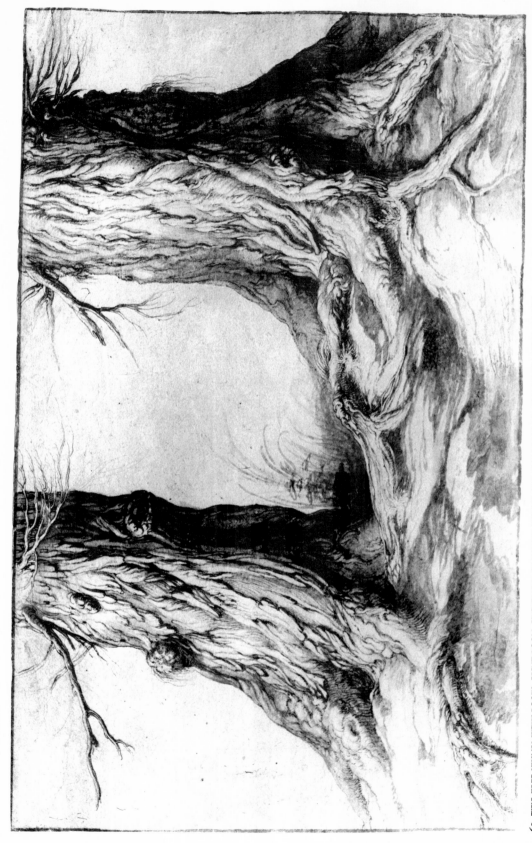

60. TWO TREE STUMPS WITH ROOTS. PRINT ROOM, UNIVERSITY OF LEIDEN, LEIDEN. PEN AND WASH ON GREY PAPER: 253 × 390 MM.

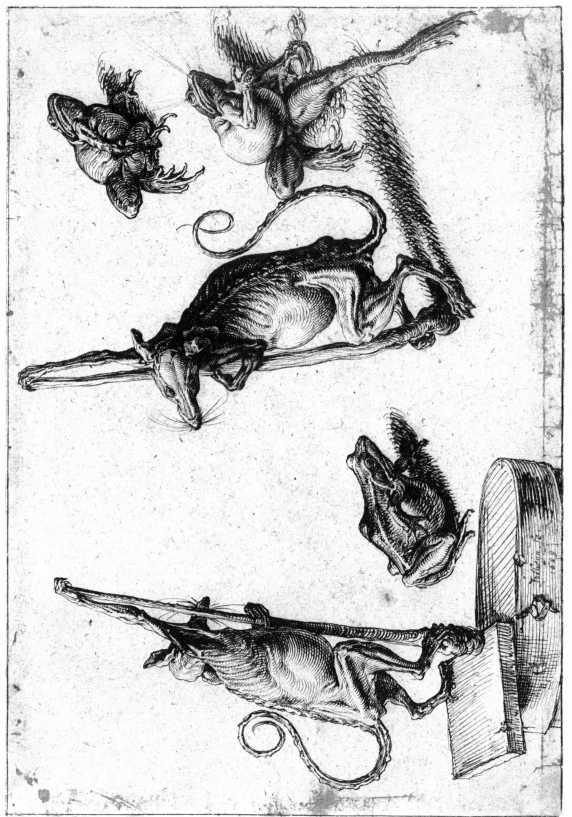

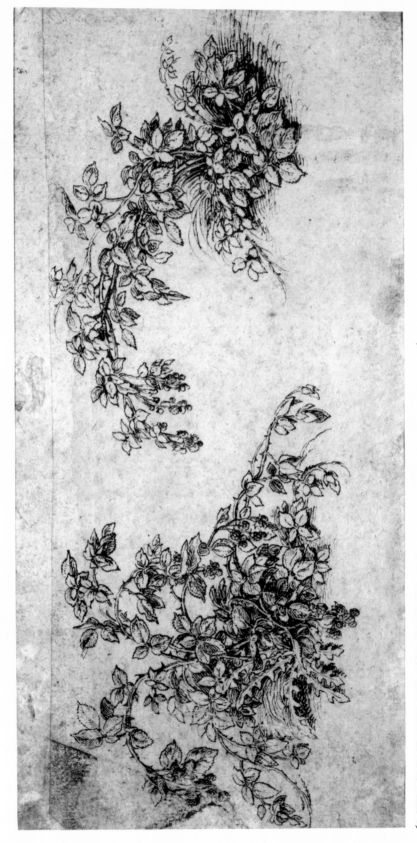

62. STUDY OF BLACK BERRIES, PRINT ROOM, RIJKSMUSEUM, AMSTERDAM. PEN AND INK ON GREY-BROWN PAPER: 163 × 302 MM.

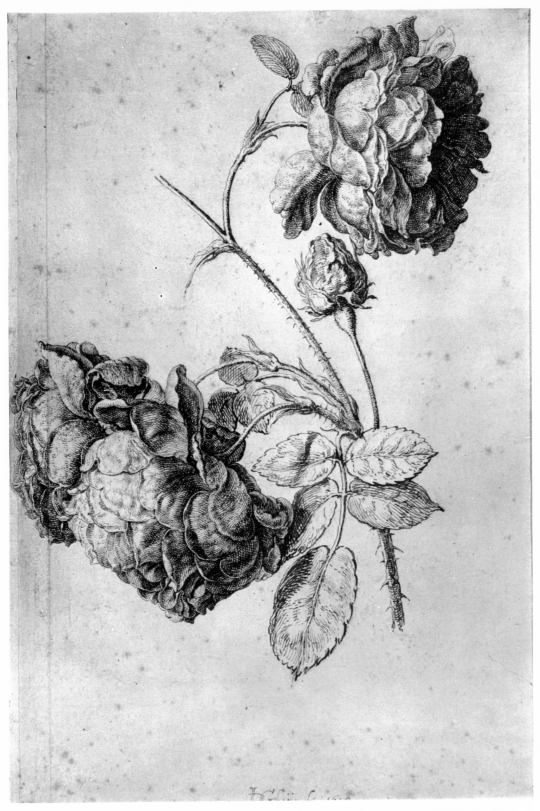

63. THREE ROSES, PRINT ROOM, STAATLICHE MUSEEN, BERLIN. PEN AND INK: 265 × 176 MM., SIGNED AND DATED 1620 IN
BOTTOM CENTER.

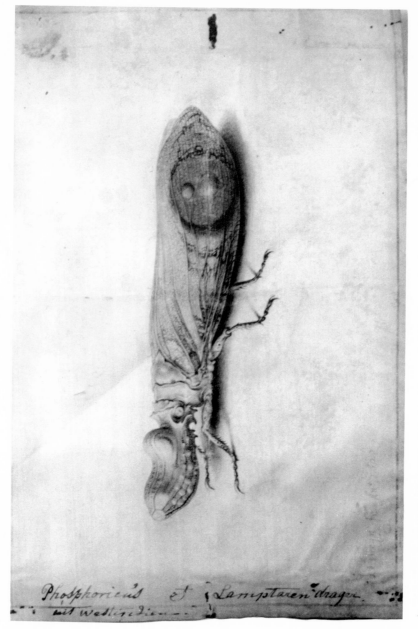

64. STUDY OF AN INSECT, FOUNDATION P. & N. DE BOER, AMSTERDAM. PEN, INK AND WASH ON VELLUM: 115 × 168 MM., SIGNED AND DATED 1620 IN LOWER LEFT CORNER AND INSCRIBED ALONG LEFT MARGIN: "PHOSPHORICUS ET LAMPTAREN DRAGEN UIT WESTINDIEN..."

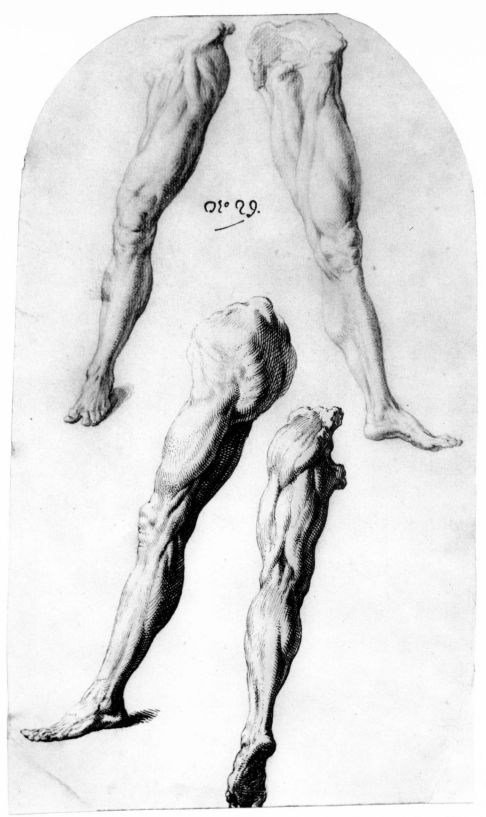

65. STUDY OF LEGS, DUTCH INSTITUTE, COLLECTION F. LUGT, PARIS. PEN, INK AND BLACK CHALK: 362 × 219 MM.

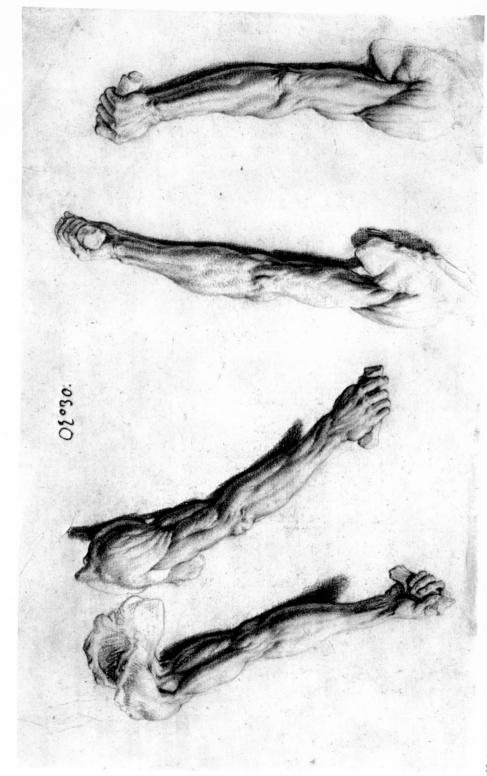

66. STUDY OF ARMS, PRINT ROOM, RIJKSMUSEUM, AMSTERDAM. BLACK CHALK: 360 × 231 MM.

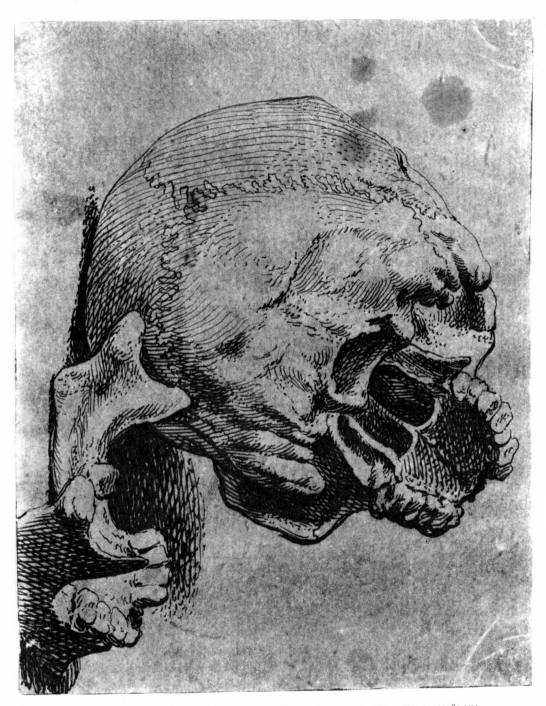

67. STUDY OF A SKULL, PRINT ROOM, STAATLICHE MUSEEN, BERLIN. PEN AND INK ON GREY PAPER: 141 × 182 MM.

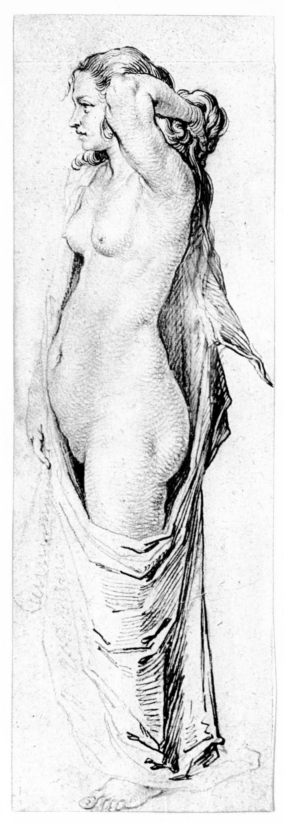

68. STANDING WOMAN AT HER TOILET, DUTCH INSTITUTE, COLLECTION
F. LUGT, PARIS. PEN, INK AND BLACK CHALK: 265 × 89 MM.

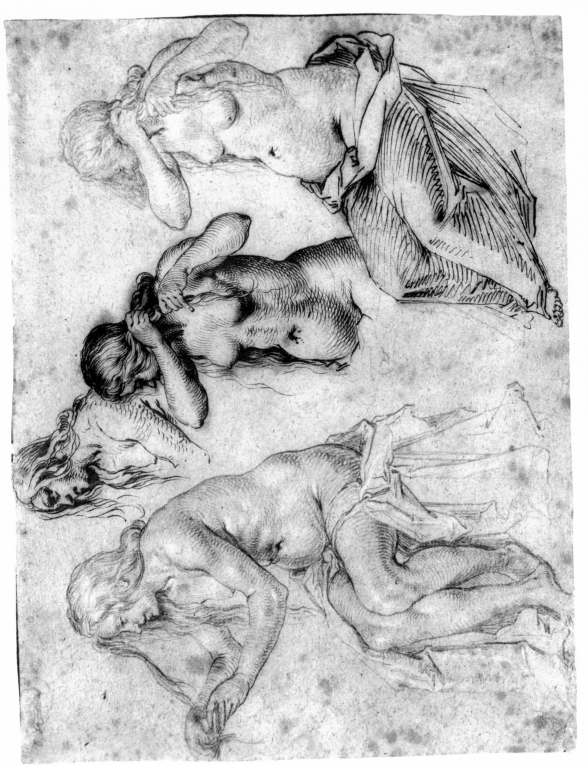

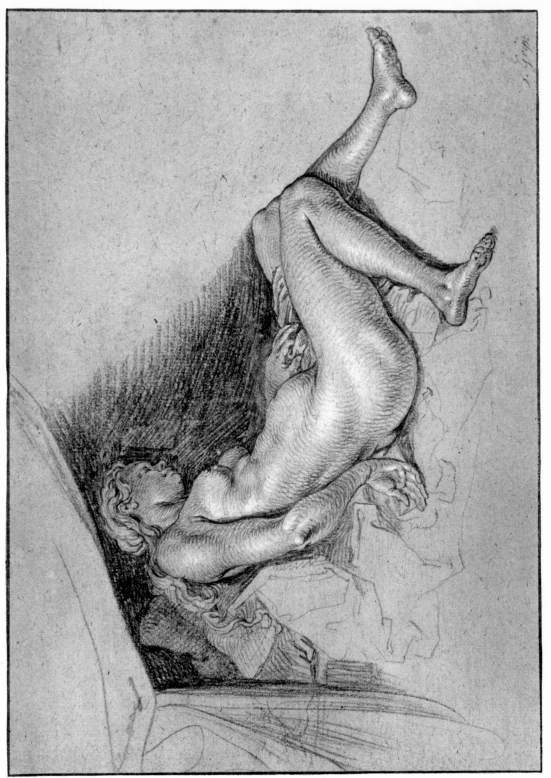

70. SLEEPING WOMAN, PRINT ROOM, DUKE ANTON ULRICH-MUSEUM, BRUNSWICK. BLACK AND WHITE CHALK ON GREY PAPER: 221 × 303 MM., SIGNED BOTTOM RIGHT CORNER.

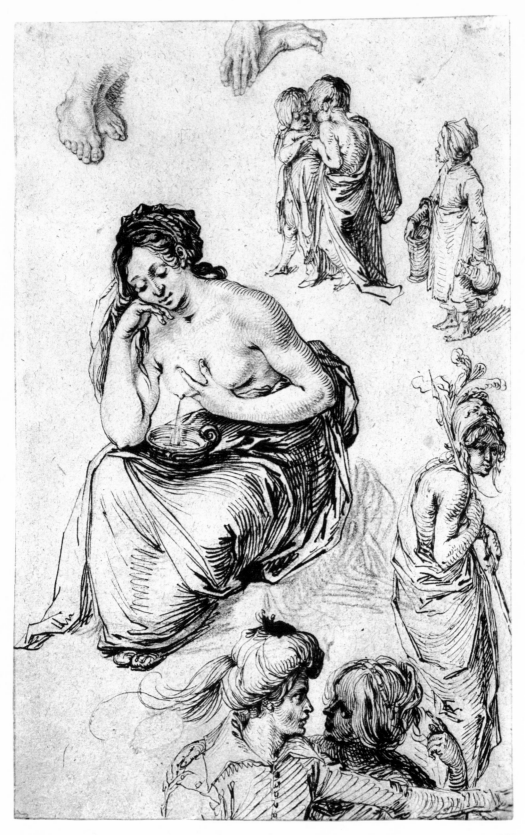

71. SHEET OF STUDIES, HESSISCHES LANDESMUSEUM, DARMSTADT. PEN, INK AND BLACK CHALK WITH TRACES OF RED CHALK IN
FEET AT TOP LEFT: 381 × 248 MM.

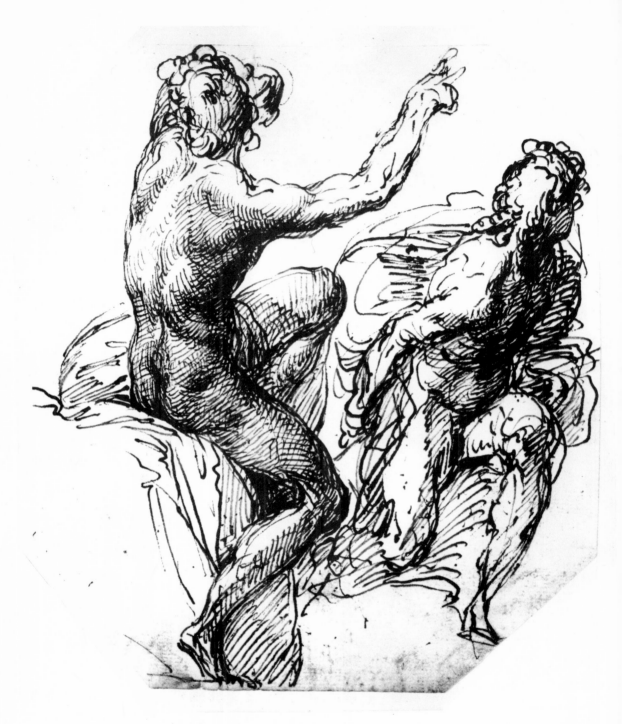

72. FIGURE STUDIES AFTER MICHELANGELO, ALBERTINA, VIENNA. PEN AND INK: 171 × 156 MM.

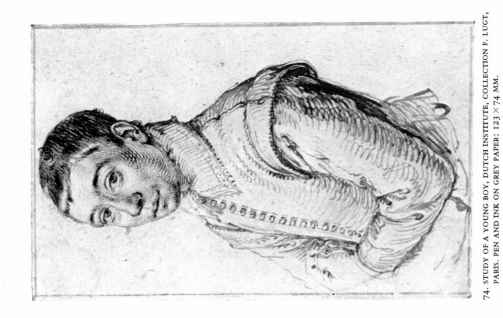

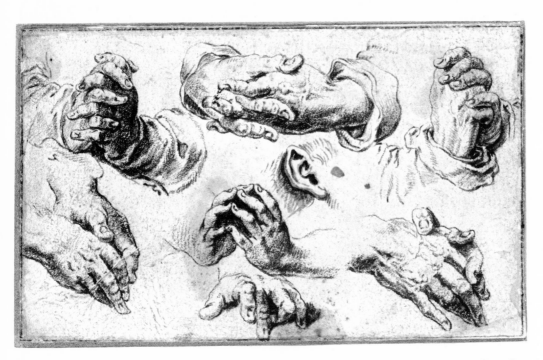

73. STUDY OF HANDS, FORMERLY COLLECTION SIR BRUCE INGRAM. BLACK CHALK TOUCHED WITH BRUSH AROUND EAR: 83 × 138 MM.

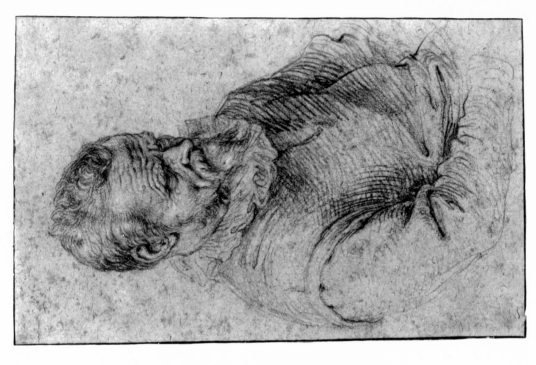

76. STUDY OF SEATED MAN, TEYLER FOUNDATION, HAARLEM. BLACK CHALK
ON GREY PAPER: 165 × 89 MM.

75. STUDY OF SHEPHERDESSES, PRINT ROOM, STAATLICHE MUSEEN, BERLIN.
SILVER-POINT ON WHITE GROUND: 89 × 82 MM.

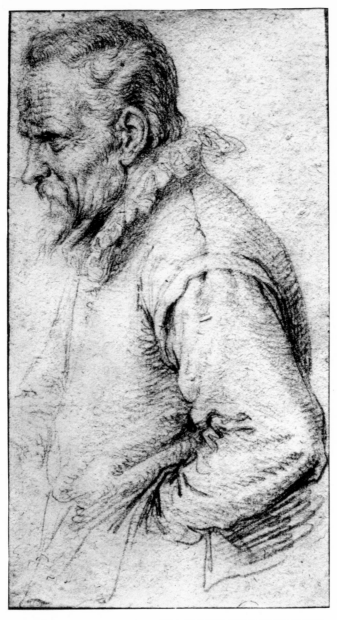

77. STUDY OF A MAN, TEYLER FOUNDATION, HAARLEM. BLACK CHALK ON GREY
PAPER: 165×89 MM.

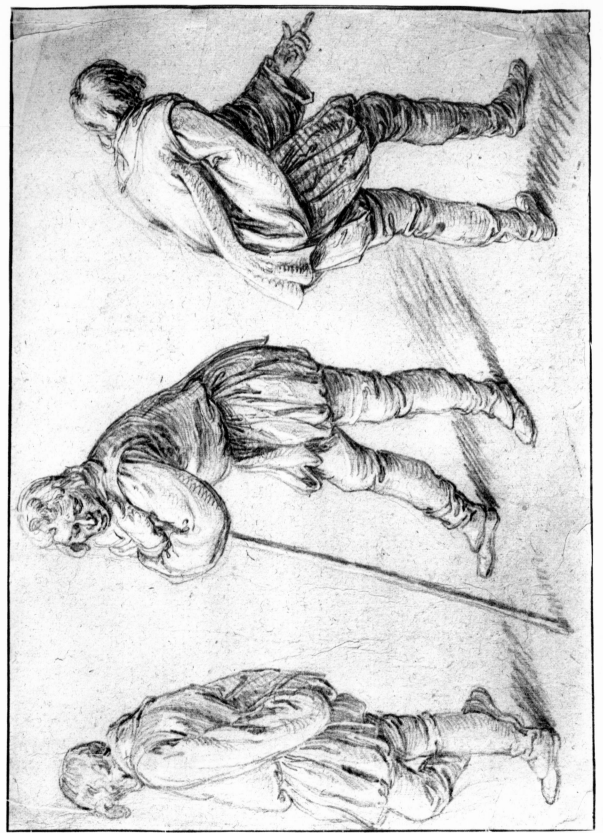

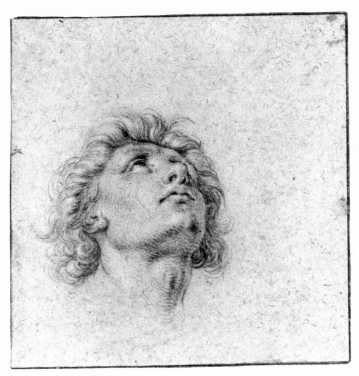

79. STUDY OF A HEAD, GEMEENTE MUSEUM, COLLECTION FODOR, AMSTERDAM.
BLACK CHALK ON GREY PAPER: 94 × 92 MM.

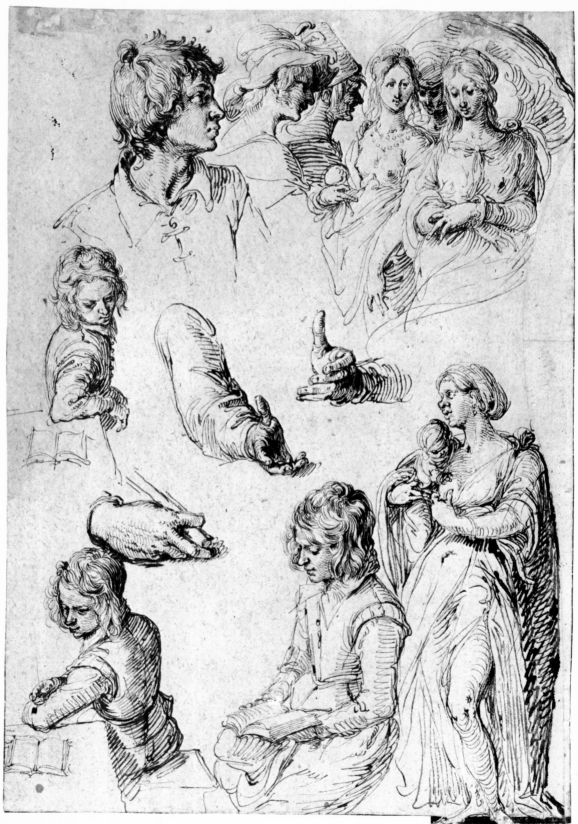

80. STUDY OF FIGURES AND HANDS, PRINT ROOM, RIJKSMUSEUM, AMSTERDAM. PEN AND INK ON BROWN-GREY PAPER: 361 × 259 MM.

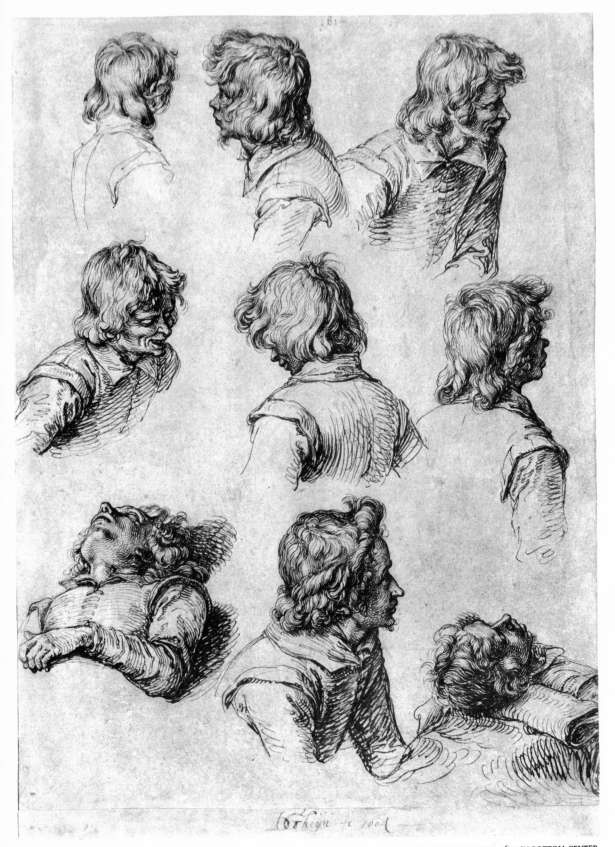

81. STUDY OF NINE HEADS, PRINT ROOM, STAATLICHE MUSEEN, BERLIN. PEN AND INK: 362 × 260 MM., SIGNED AND DATED 1604 IN BOTTOM CENTER.

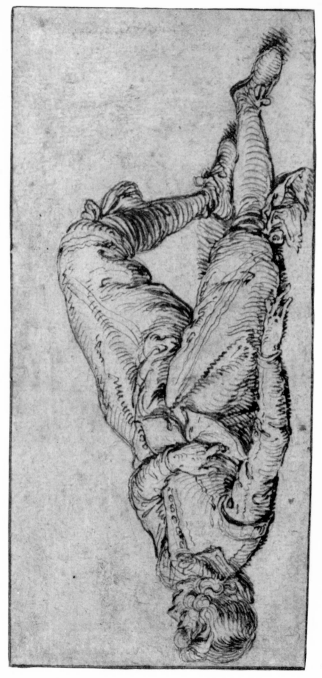

82. STUDY OF A YOUNG MAN RESTING ON THE GROUND, PRINT ROOM, STAATLICHE MUSEEN, BERLIN. PEN AND INK: 82 × 176 MM.

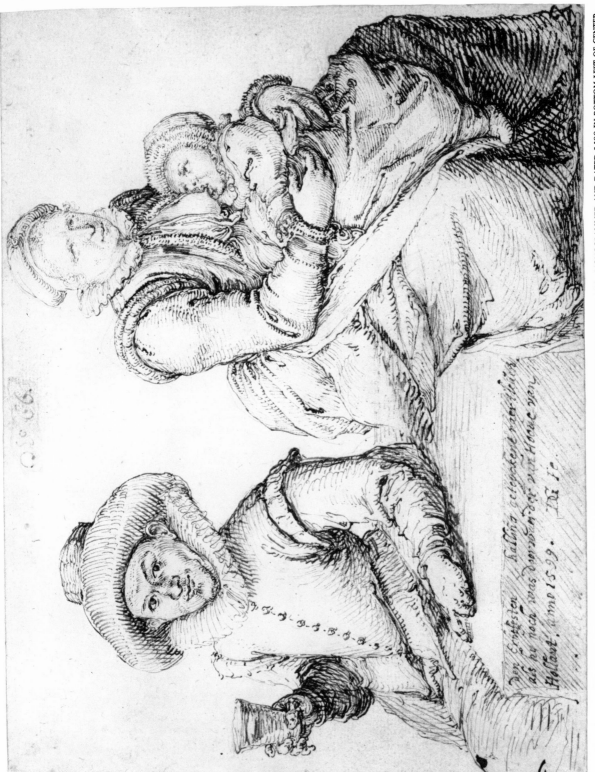

83. BAILIFF HALLING WITH HIS WIFE AND CHILD[?], PRINT ROOM, RIJKSMUSEUM, AMSTERDAM. PEN AND INK: 157 × 205 MM., MONOGRAMMED AND DATED 1599 IN BOTTOM LEFT OF CENTER.

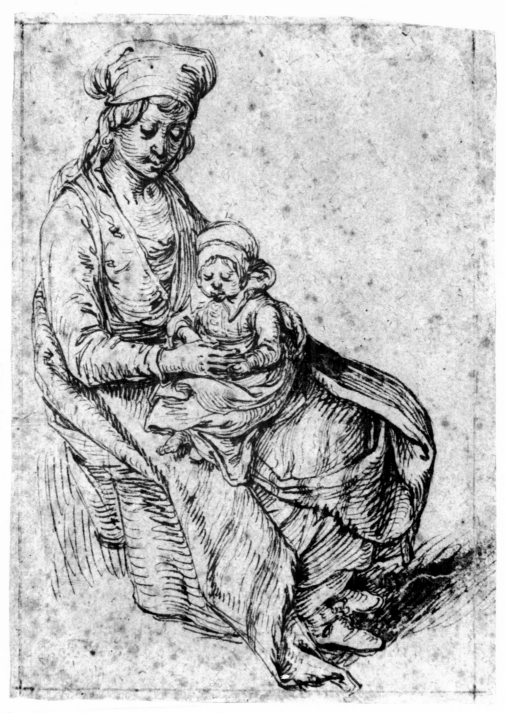

84. MOTHER HOLDING A BABY ON HER LAP, WITT COLLECTION, COURTAULD INSTITUTE OF ART, LONDON UNIVERSITY.
PEN AND INK: 183 × 135 MM.

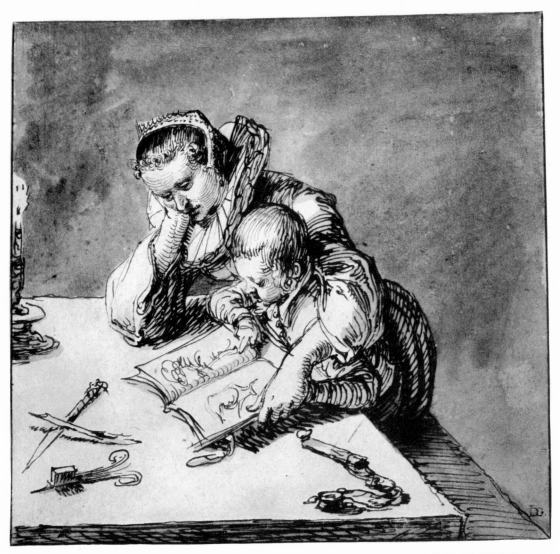

85. MOTHER AND CHILD STUDYING DRAWING BOOK, PRINT ROOM, STAATLICHE MUSEEN, BERLIN. PEN, INK AND BROWN WASH:
147 × 147 MM.

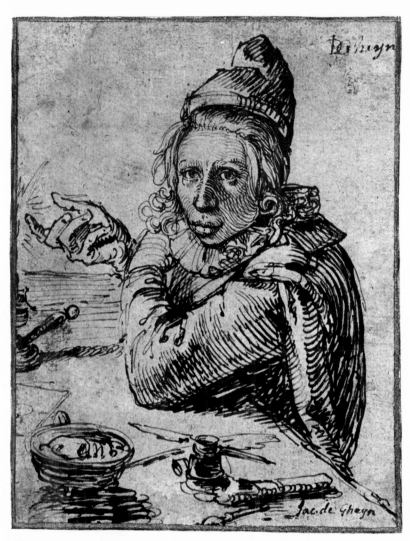

86. YOUNG ARTIST SEATED AT A TABLE, YALE UNIVERSITY ART GALLERY, NEW HAVEN, CONN. PEN AND
INK ON BROWNISH PAPER: 135 × 103 MM., SIGNED UPPER RIGHT CORNER.

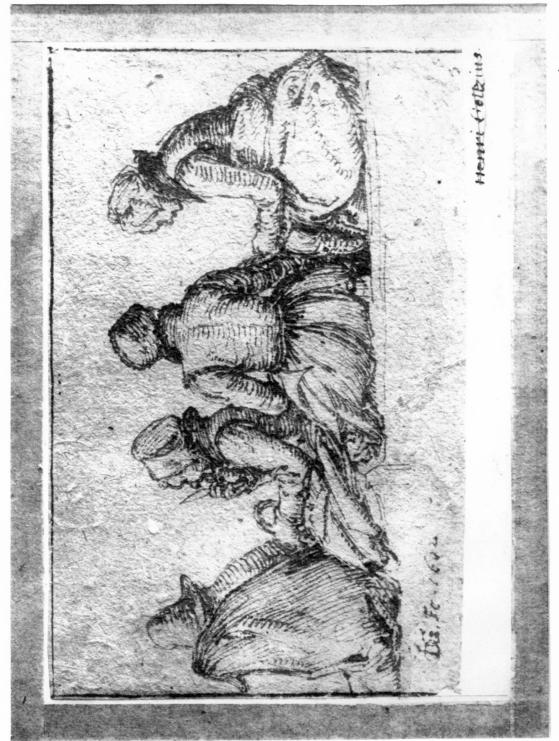

87. STUDY OF EATING FIGURES, PRINT ROOM, NATIONAL MUSEUM, STOCKHOLM. PEN AND INK ON BROWNISH PAPER: 112 × 173 MM., MONOGRAMMED AND DATED 1602 IN LOWER LEFT CORNER.

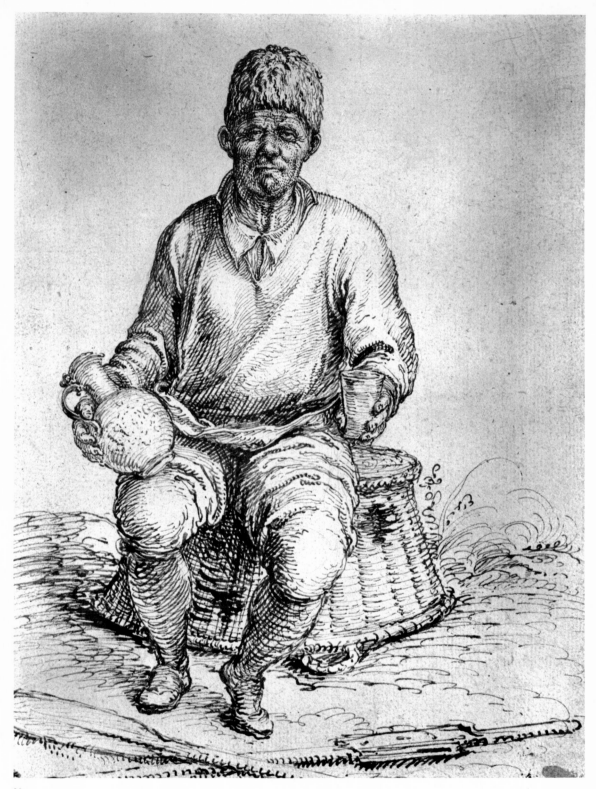

88. DRINKING FISHERMAN, MUSEUM OF OUDHEDEN, GRONINGEN. PEN, INK AND BROWN WASH: 203 × 155 MM.

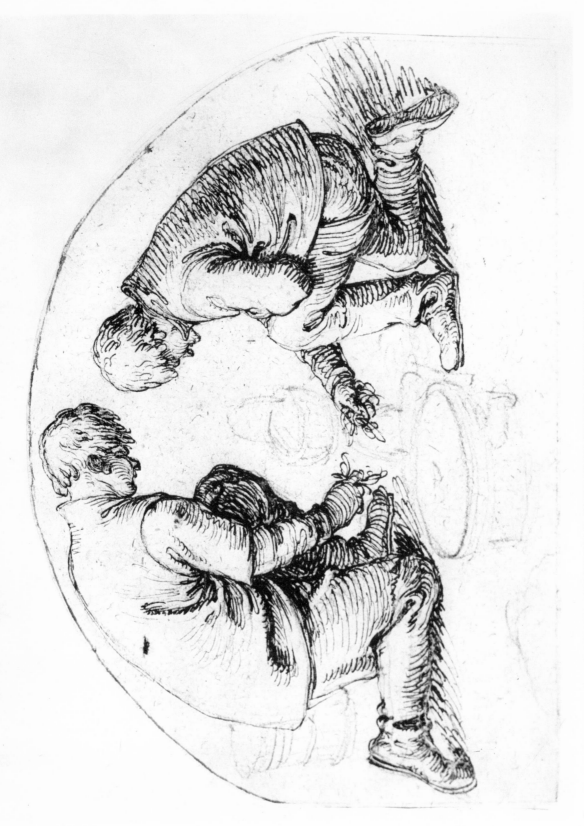

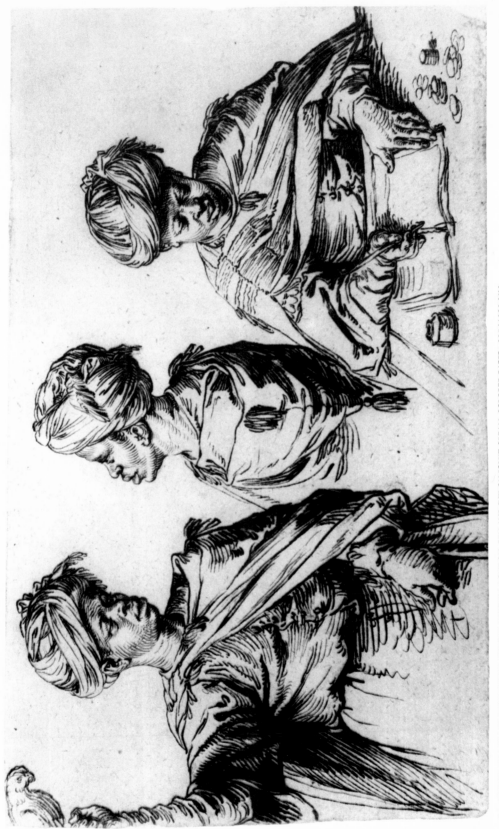

90. STUDIES OF A BLACK, PRINT ROOM, BRITISH MUSEUM, LONDON. PEN AND INK ON LIGHT CREAM-COLORED PAPER: 201 × 320 MM.

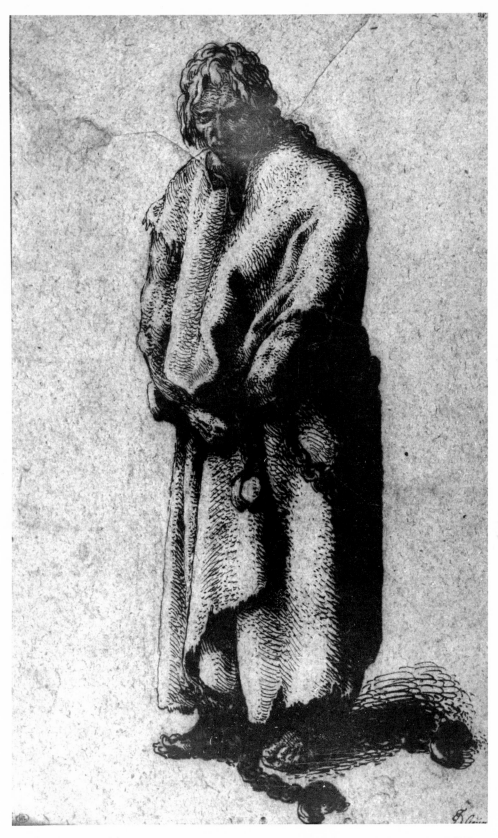

91. JACOB DE GHEYN II[?], STUDY OF A PRISONER, PRINT ROOM, LOUVRE MUSEUM, PARIS. PEN, INK AND BROWN WASH ON GREY PAPER: 361 × 222 MM.

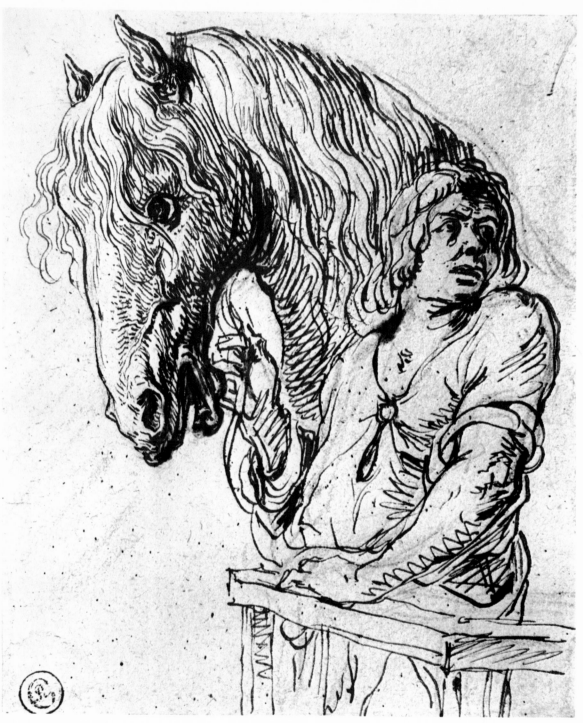

92. MAN HOLDING A HORSE, PRINT ROOM, BRITISH MUSEUM, LONDON. PEN AND INK OVER BLACK CHALK ON LIGHT CREAM–COLORED PAPER: 197 × 163 MM.

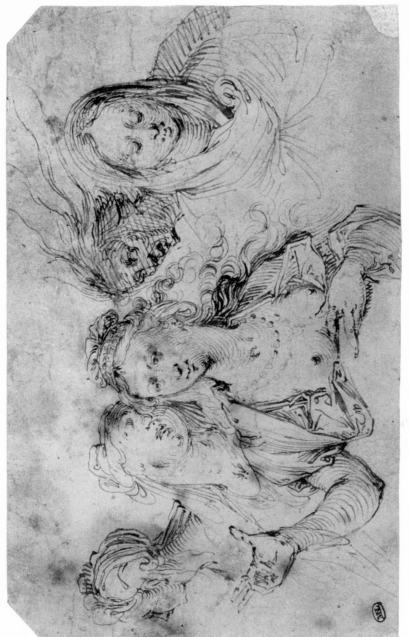

93. STUDY OF YOUNG WITCHES, PRINT ROOM, LOUVRE MUSEUM, PARIS. PEN AND INK: 168 × 108 MM.

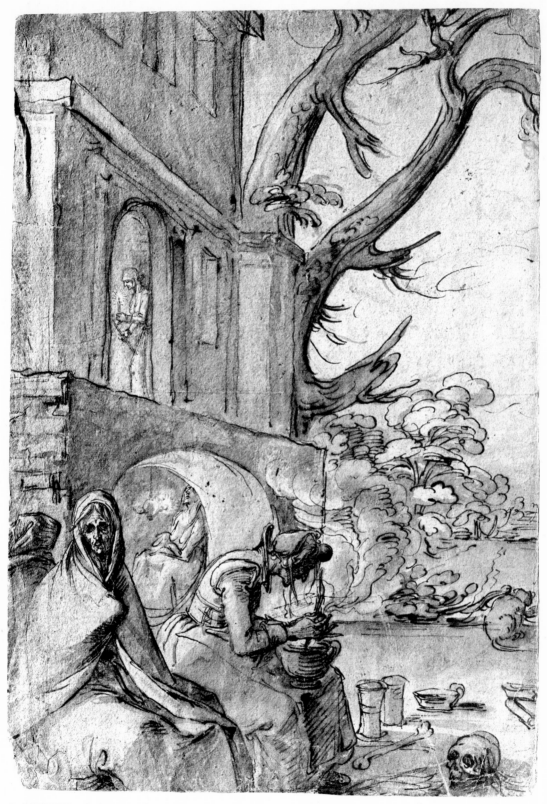

94. PREPARATION FOR THE SABBATH, CHRIST CHURCH, OXFORD. PEN, INK AND GREY-BROWN WASH: 380×259 MM.

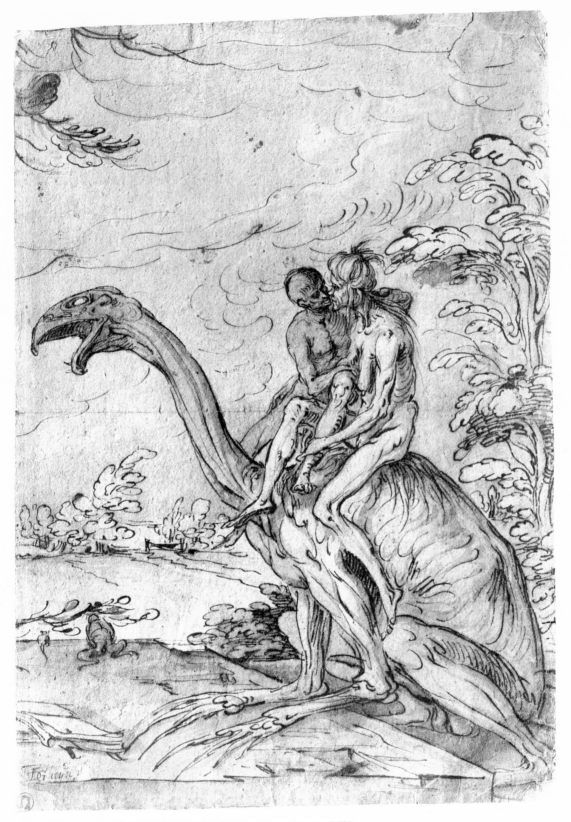

95. RIGHT HALF OF FIG. 94. SAME TECHNIQUE AND SIZE. SIGNED IN BOTTOM CENTER.

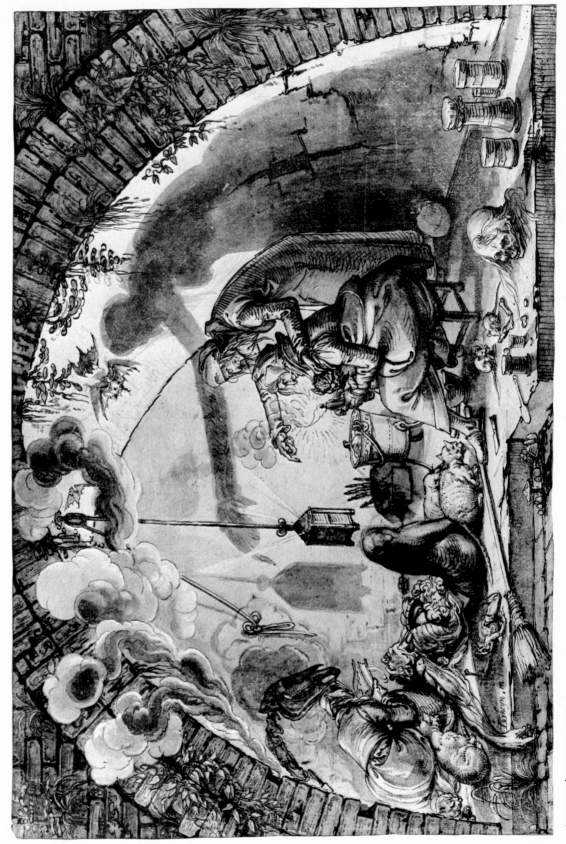

96. WITCHES' SABBATH, ASHMOLEAN MUSEUM, OXFORD. PEN, INK AND GREY-BROWN WASH: 280 × 408 MM., SIGNED AND DATED 1600 IN BOTTOM LEFT OF CENTER.

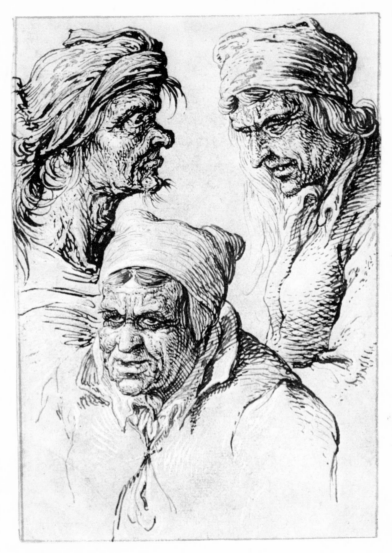

97. STUDY OF THREE HAGS, TEYLER FOUNDATION, HAARLEM. PEN, INK AND WHITE CHALK
HIGHLIGHTS: 138 × 97 MM.

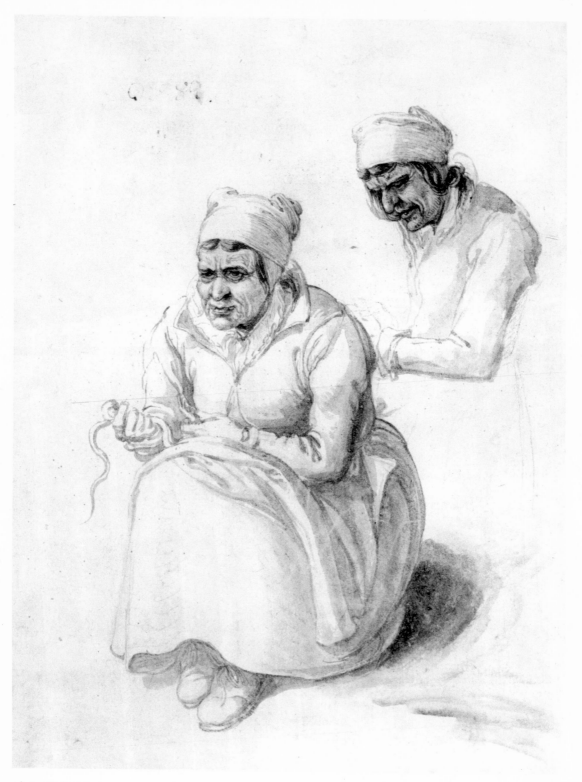

98. STUDY OF TWO OLD WOMEN, DUTCH INSTITUTE, COLLECTION F. LUGT, PARIS. PEN, INK, WASH AND WATERCOLOR: 210 × 150 MM.

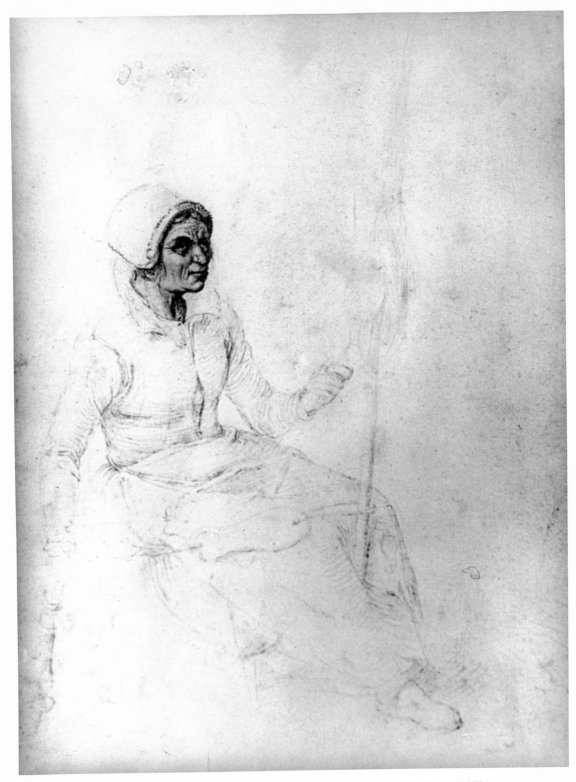

99. STUDY OF OLD WOMAN SPINNING, A. F. DREY, LONDON, 1951. SILVER-POINT ON PREPARED PAPER: 200 × 150 MM.

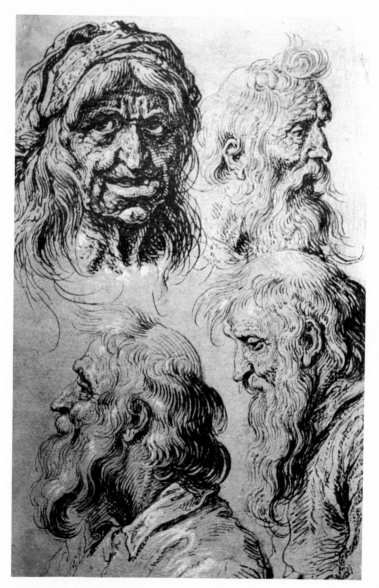

100. STUDY OF FOUR HEADS, TEYLER FOUNDATION, HAARLEM. PEN AND INK OVER
CHARCOAL, WHITE CHALK HIGHLIGHTS: 147 × 96 MM.

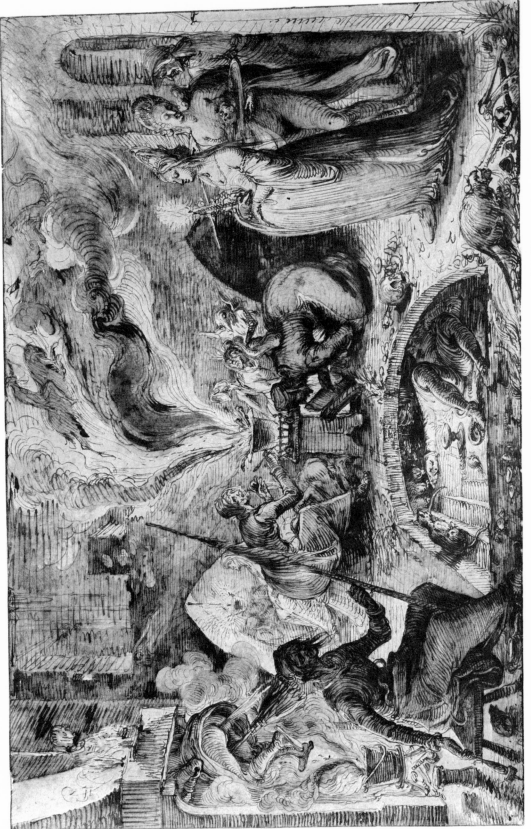

IOI. PREPARATION FOR THE SABBATH, PRINT ROOM, STAATLICHE MUSEEN, BERLIN. PEN, INK AND WASH: 265 × 410 MM., SIGNED IN BOTTOM LEFT.

102. STUDY OF CLOAKED FIGURE, DUTCH INSTITUTE, COLLECTION F. LUGT, PARIS. PEN AND INK:
120 × 104 MM.

103. STUDY OF SEATED FIGURE, COLLECTION PROFESSOR J. Q. VAN REGTEREN ALTENA, AMSTERDAM. PEN, INK AND BLACK CHALK: 257 × 191 MM.

104. FORTUNE TELLER, DUKE ANTON ULRICH–MUSEUM, BRUNSWICK. PEN, INK AND GREY WASH: 269 × 209 MM., SIGNED BOTTOM LEFT.

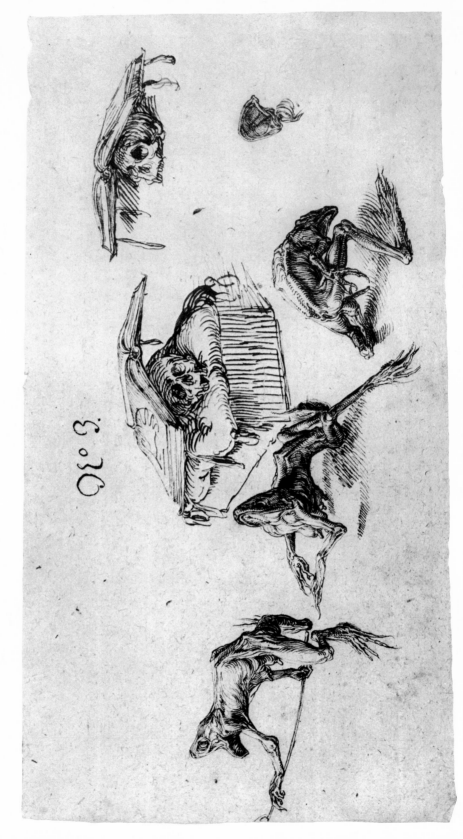

veryLow106. STUDY OF ATTRIBUTES USED IN WITCHCRAFT, DUTCH INSTITUTE, COLLECTION F. LUGT, PARIS. PEN, INK AND BLACK CHALK ON GREY PAPER: 191 × 354 MM.

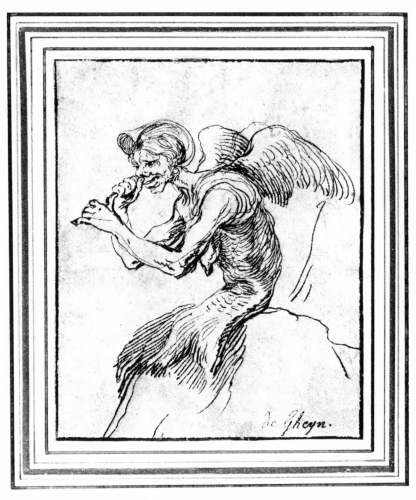

107. FANTASTIC CREATURE, COLLECTION DE GREZ, ROYAL MUSEUM, BRUSSELS. PEN AND INK:
100 × 84 MM.

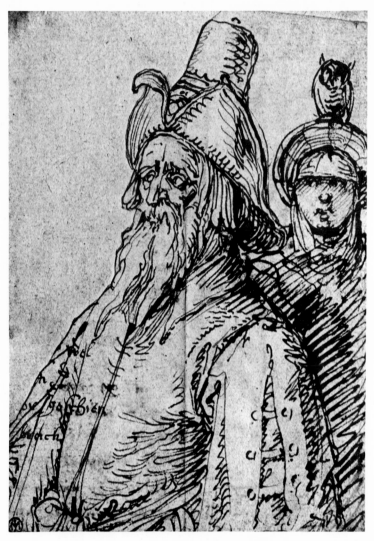

108. ALLEGORY[?], PRINT ROOM, ECOLE DES BEAUX-ARTS, PARIS. PEN AND INK: 136×98 MM.

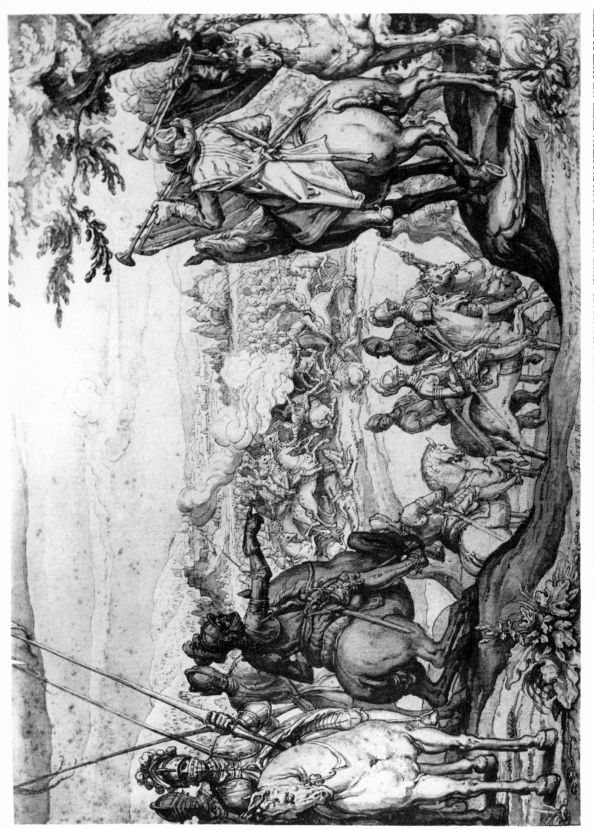

109. CAVALRY CHARGE, PRINT ROOM, MUSEUM BOYMANS–VAN BEUNINGEN, ROTTERDAM. PEN, INK AND GREY WASH: 159 × 213 MM., SIGNED AND DATED 1599 IN BOTTOM CENTER AND RIGHT OF CENTER.

110. TRUMPETER, PRINT ROOM, RIJKSMUSEUM, AMSTERDAM. PEN, INK, GREY AND BROWN WASH ON GREY PAPER: 140 × 140 MM.

III. STUDY FOR A GROTTO, THE PIERPONT MORGAN LIBRARY, NEW YORK. PEN, INK AND GREY WASH OVER SLIGHT INDICATIONS IN BLACK CHALK: 181 × 301 MM.

The text of this volume has been offset
from the limited edition printed by
The Gehenna Press in Northampton, Massachusetts.
It was set in Monotype Bembo. The pressman was
Harold McGrath. Both the text and the plates
have been printed by The Meriden Gravure Company
in Meriden, Connecticut.
The paper is Mohawk Vellum.

The book was designed by Leonard Baskin.